Infernal Methods

A STUDY OF
WILLIAM BLAKE'S ART TECHNIQUES

Earlier books on related subjects
also by Raymond Lister

Beulah to Byzantium (Dolmen Press)
Edward Calvert (Bell)
William Blake (Bell)
Samuel Palmer and his Etchings (Faber)
Samuel Palmer: A Biography (Faber)
The Letters of Samuel Palmer (Clarendon Press)
British Romantic Art (Bell)

Infernal Methods

A Study of William Blake's Art Techniques

RAYMOND LISTER

London

G. BELL & SONS LTD

ISBN 0 7135 1845 6

Printed in Great Britain by
The Camelot Press Ltd, Southampton

THIS BOOK
IS DEDICATED TO THE MEMORY OF
EDWIN SMITH
ARTIST, PHOTOGRAPHER,
AND ADMIRER OF BLAKE

ACKNOWLEDGEMENTS

I am grateful to those who have answered questions and made suggestions in connexion with this book, especially Sir Geoffrey Keynes, Mr David Gould, Mr Malcolm Cormack and Mr Reginald Williams. I am also grateful to my wife, Pamela, for much practical help.

R. L.

Linton,
Cambridgeshire

Contents

Illustrations

. . . the notion that man has a body distinct from his soul is to be expunged; this I shall do by printing in the infernal method, by corrosives, which in Hell are salutary and medicinal, melting apparent surfaces away, and displaying the infinite which was hid.

William Blake
The Marriage of Heaven and Hell

Abbreviations

Books frequently quoted in the footnotes are abbreviated as follows. Full details appear in the Bibliography.

Blake Newsletter	Quarterly journal published at the Department of English of the University of New Mexico.
Blake Records	Bentley, G. E., Jr, *Blake Records*.
Blake Studies	Semi-annual journal published at Illinois State University, Normal, Illinois. Not to be confused with Keynes, *Blake Studies* below.
Gilchrist	Gilchrist, Alexander, *Life of William Blake*.
K. followed by a number	Keynes, Geoffrey, *The Complete Writings of William Blake*. The number refers to the page.
Keynes *Blake Studies*	Keynes, Geoffrey, *Blake Studies*; not to be confused with *Blake Studies* above.

In other cases, where full details are not given, sufficient details are provided in the footnotes to allow the work to be identified in the Bibliography.

I

Introduction

THIS book does not set out to explain or interpret the symbolic or philosophic content of the work of William Blake. There are already plenty of such books, many of them excellent additions to Blake scholarship, although it must also be admitted that others give a clearer indication of the ideas and prejudices of their authors than about those of Blake.

The present book is concerned with but one facet of Blake's work yet it is a fundamentally important one—the techniques used by him in creating his visual art.

It is no exaggeration to claim that properly to understand the work of any artist, it is imperative to understand his techniques. This is particularly so in the case of such an artist as Blake, in which they bear such vast symbolic potential. Nevertheless, comment has, so far as possible, been restricted to the ways and means of those techniques, and symbolism is brought into the discussion only where it has a direct bearing on them.

Yet, because Blake's techniques, like everything he touched, took on symbolism, it has been impossible to avoid some discussion of it. Nor have I shirked to mention it where it has been necessary, while endeavouring to leave the accent on Blake's craftsmanship. But I have avoided the discussion of subjects such as the symbolism of Blake's colours or of the forms of his lettering, of the gestures and stances of his figures, of the relevance of his designs to his ideas of contraries, and so on, deeming it of greater importance in the present context to dwell on *how* rather than on *why* things were done.

That is, of course, not to say that consideration of Blake's symbolism is valueless. On the other hand, such consideration is essential for a

full understanding of his work; but there are many scholars more capable than myself of dealing with that aspect of Blake.

Nor is this book about Blake's artistic sources. That side of his work is of great and absorbing interest,[1] but it is better not to complicate the consideration of Blake's techniques by introducing, except in an occasional aside, a discussion of them here. I feel that those sources—for instance, the influence of Oriental art—have by no means been exhaustively investigated, but they demand separate study.

I have therefore confined myself to a side of him that to me, as an artist and craftsman, has always been fascinating—his tremendous versatility as a practical workman, and it is this which I shall hope to illustrate in these pages.

That versatility is one of the most immediately striking aspects of Blake's artistry. He was in many ways the equivalent in the visual arts of the eighteenth-century polymath, turning with equal facility from line engraving to etching, from wood engraving to lithography, from water-colour to what he called fresco (actually a form of tempera) and from thence to miniature. Nor was this all, for he invented or adapted with great originality a number of techniques, such as colour-printing and relief-etching, in which he conceived some of his most characteristic work.

Blake was supremely aware of his originality: 'I know', he said, 'my Execution is not like Any Body Else. I do not intend it should be so; none but Blockheads Copy one another. My Conception & Invention are on all hands allow'd to be Superior. My Execution will be found so too.'[2] And if that sounds aggressive, we should recall that it was written during a period of neglect, in which he was all but forgotten by most of the world. Yet its content remains true for, although we know that he tapped many sources for his conceptions, those sources were always given something fresh by their passage through his genius. It is one object of the present work to show that it is also true of his execution.

Few artists have written about their techniques so widely as Blake; his poetry and prose abound in allusions to his methods. In one place he writes:

1. See, for example, Blunt, *The Art of William Blake.*
2. *Public Address*, K.601.

Let a Man who has made a drawing go on & on & he will produce a Picture or Painting, but if he chooses to leave it before he has spoil'd it, he will do a Better Thing.[3]

In another place we are told:

Minute Discrimination is Not Accidental. All Sublimity is founded on Minute Discrimination.

I do not believe that Rafael taught Mich. Angelo, or that Mich. Angelo taught Rafael, any more than I believe that the Rose teaches the Lilly how to grow, or the Apple tree teaches the Pear tree how to bear Fruit. I do not believe the tales of Anecdote writers when they militate against Individual Character.[4]

And in yet another place, and on a different level, he declares that,

> ... Art & Science cannot exist but in minutely organized Particulars
> And not in generalizing Demonstrations of the Rational Power.
> The Infinite alone resides in Definite & Determinate Identity.[5]

So, throughout his work, such comments and allusions continue, demonstrating how intimate to Blake was his technique. It is, of course, a truism to say that to any artist his technique is an intimate part of his work. But to Blake it was even more, assuming in his case an almost mystical significance:

A Poet, a Painter, a Musician, an Architect: the Man Or Woman who is not one of these is not a Christian.
You must leave Fathers & Mothers & Houses & Lands if they stand in the way of Art.
Prayer is the Study of Art.
Prayer is the Practise of Art.
Fasting &c., all relate to Art.
The outward ceremony is Antichrist.
The Eternal Body of Man is The Imagination, that is,
God himself ⎫
The Divine Body⎭ יֵשׁוּעַ, Jesus: we are his Members.
It manifests itself in his Works of Art (In Eternity All is Vision).[6]

3. Ibid., K.603. 4. *Annotations to Sir Joshua Reynolds's Discourses*, K.453.
5. *Jerusalem*, K.687 6. *The Laocoon*, K.776.

Although we shall in this book be making only passing references to this aspect of Blake's technique, it will be well to remind ourselves at the outset of its importance to the artist. To him, every stroke of the brush, every incision of the graver, every scratch of the etching needle, was charged with meaning beyond its simple mechanics, being media by which 'the doors of perception [may be] cleansed [in order that] every thing would appear to man as it is, infinite'.[7]

7. *The Marriage of Heaven and Hell*, K.154.

2

Engraving

WILLIAM BLAKE was a professional engraver. Almost everything he did in the visual arts was conditioned by that fact. The vision of an engraver is discernible in his water-colours, in his temperas, in his drawings, in his relief-etchings and in work in techniques related to them. Even his ideas on what was admissible or inadmissible in the visual arts were influenced by it.

This is not surprising, for Blake's training in his craft was thorough. He had, at an early age, ambitions to become an artist, and his ability was such, that at the age of ten he was sent for lessons in drawing to Henry Pars's academy in the Strand, where he made studies of plaster casts of antique statuary. Blake's father also bought him casts so that he could practise drawing at home. What was to be of even greater importance, he gave him money with which to buy prints, thus enabling him to lay the foundations of an extensive collection which only penury in old age forced him to sell. Some of these he bought from print dealers and in the auction rooms; a large number were acquired by the boy from the auctioneer Langford, who used to call Blake his little connoisseur, and often knocked a cheap lot down to him.[1]

When the time came for William to be put to a profession or trade, enquiries were made to an unnamed but reputedly well-known painter about placing the boy under him, but the premium was more than his father could afford. In the end it was decided to put him to the engraver's trade, and he was bound apprentice for seven years to James Basire I, a member of a noted dynasty of engravers and successor of George Vertue as engraver to the Society of Antiquaries.

Basire had worked with Henry Pars, and with Pars's younger

1. Tatham, Frederick, *Life of Blake* (*c.* 1832), *Blake Records*, p. 510; Malkin, Benjamin Heath, *A Father's Memories of His Child* (1806). Ibid., pp. 421–22.

brother, William, on the illustration of certain books, and this, taken in conjunction with the fact that it was the practice of Pars's school to introduce pupils to prospective masters, makes it probable that Blake and his father were introduced to Basire in this way.[2]

The apprenticeship, the premium for which was £52.10s., was registered on 4 August 1772, in the Apprentice Register at Stationers' Hall, so that Blake was nearly fifteen years old at the time.[3] Even after his apprenticeship had ended, Blake continued to learn, for he was registered as an engraving student at the Royal Academy in 1779, and he was still a student there in 1780.[4]

During his seven years with Basire, Blake must have explored every nuance of the engraver's and etcher's techniques, for in time he came to handle them with remarkable dexterity. His works in these media range from reproductive work after the designs of other artists (and line-engraving combined with etching was used more than any other technique for this in Blake's time), through lightweight and sometimes apparently crude work, to that sublime masterpiece of the engraver's art, considered by some to be Blake's greatest visual work, his *Illustrations of the Book of Job*, which, wrote John Ruskin, 'is of the highest rank in certain characters of imagination and expression; in the mode of obtaining certain effects of light it will also be a very useful example. . . . In expressing conditions of glaring and flickering light, Blake is greater than Rembrandt.'[5] This enormous range, combined with a controlled variation of technique, is indicative of the thoroughness of Blake's training.

It is impossible with any certainty to trace much of the work done by Blake during his apprenticeship, for it was all issued under Basire's name. Nevertheless there is a certain amount of circumstantial evidence that he worked on some of Basire's engravings for Jacob Bryant's *New System, or An Analysis, of Ancient Mythology* (1774–76),[6] and Richard Gough's *Sepulchral Monuments of Great Britain*, Part 1 (1786)

2. See note by Nancy Bogen, *Notes and Queries*, New Series, Vol. 17, No. 8, pp. 313–14.

3. Keynes, *Blake Studies*, p. 14.

4. Register of Entrants at the Royal Academy, *Walpole Society*, XXXVIII, 1962, p. 130. Quoted in Bindman, David, *Blake Fitzwilliam Catalogue*, p. 61, n.1.

5. Ruskin, John, *The Elements of Drawing in Three Letters to Beginners*, new edn, London, 1892, pp. 344–45. In the opinion of Laurence Binyon, Blake's *Job* was 'the one great achievement in [the art of line engraving] since Dürer'. *Engraved Designs of William Blake*, pp. 7–8.

6. Todd, Ruthven, *Tracks in the Snow*, London, 1946, pp. 30–41.

(Plate 1) and he doubtless worked on others. Some preliminary drawings for *Sepulchral Monuments* are in the Bodleian Library, and Sir Geoffrey Keynes has listed nineteen of these that he considers are probably by Blake.[7]

Certainly Blake made such drawings. After he had served two years of his apprenticeship, other apprentices were taken into the establishment; but for some reason they struck a discordant note. Blake's sympathies were apparently with his master, but at the same time he did not want to take sides against his fellow apprentices, so Basire sent him out to make drawings of the tombs and effigies in Westminster Abbey. Such was Blake's energy in doing this that Benjamin Heath Malkin, who wrote an early biographical sketch of him, commented: '. . . I do not mean to enumerate all his drawings [of this period], since they would lead me over all the old monuments in Westminster Abbey, as well as over other churches in and about London.'[8]

So here again, we have a glimpse of the thoroughness of Blake's training. Not only was he trained as an engraver, but he also learned the art of making drawings suitable for an engraver to work from, such drawings having different emphases from others, being executed in washes accentuating tonal values that make it easier for an engraver to translate them into lines, dots and strokes, as they may demand.[9]

The earliest plate on record, engraved and signed by Blake, is his *Joseph of Arimathea among the Rocks of Albion*,[10] engraved in 1773, about a year after the commencement of his apprenticeship, and about a year before he began working on the illustrations for *Sepulchral Monuments*. It is based on a figure in an engraving by Nicolas Beautrizet after the fresco by Michelangelo of the Crucifixion of St. Peter in the Capella Paolina in the Vatican (Plate 2). It is a competent work for a boy of sixteen, although it lacks the strength of the second state of the work which Blake made in his maturity, about 1810, when he extensively reworked the plate, adding an inscription and a signature to it, but inserting the date of the plate's original state.[11]

7. Keynes, *Blake Studies*, pp. 17–18. 8. *Blake Records*, p. 423.

9. This type of drawing is illustrated by Blake's designs for his poem *Tiriel*, which, it is thought, may have been intended for engraving, although, so far as is known, they were never executed as such. See Essick, Robert N., "The Altering Eye", Paley and Phillips, *William Blake Essays in Honour of Sir Geoffrey Keynes*, p. 50.

10. Keynes, *Engravings by Blake. The separate Plates*, pp. 3–5.

11. Ibid.

This, then, was the beginning of Blake's development as an engraver, a trade which was to provide him with his main source of income throughout his life, and which, apart from giving him a position among the foremost journeyman engravers of his time, was also to provide him with the means by which his artistic development was to reach perfection.

During his training at Basire's establishment, Blake was particularly inculcated with the use of a hard, firm and wiry type of engraving, by then going out of fashion. The technique then being favoured was an apparently more facile method, tonal rather than linear, introduced from Italy by Bartolozzi and others.[12] The technique in which Blake was mainly trained was a more or less mechanical reproductive method, also Italian in origin, but one which he was able to adapt with great success to his own visionary expression.[13] It consisted of sharp, uncompromising parallel incisions of outline and cross-hatching, moulding and following the shape they were representing. Sometimes use was made of the laborious 'dot and lozenge' convention, in which the centre of each rectangle or lozenge made by the cross-hatching, is incised with a dot or small stroke, similar to the method used in the engraving of banknotes and postage stamps (Plate 3). All in all, the lines formed a complicated yet regular web that clothed the subjects of the engraving, and which, despite being abstract in itself, suggested shape and volume.[14]

But, in passing, it may be observed that Blake did not use the dot and lozenge technique merely for reproductive journeyman's work, for—and this adaptation is typical of him—he chose to use it on the frontispiece and plates 3, 4, 7 and 12 of his engraved emblem book *The Gates of Paradise* (1793), where it may perhaps (especially on plate 3) accentuate the symbolic content of the work (Plate 4). On this plate a figure is shown, completely surrounded by a heavy dot and lozenge network which may symbolise a variation on the mundane egg, imprisoning man's striving for spiritual vision.[15] Yet at the same time he despised it when used as an end in itself, as may be seen in this passage from his *Public Address*:

12. Blunt, op. cit., p. 3.
13. Hayter, *New Ways of Gravure*, p. 204.
14. Ivins, *Prints and Visual Communication*, Chapter III.
15. Cf. Essick, Robert N., 'Blake and the Traditions of Reproductive Engraving', *Blake Studies*, Vol. 5, No. 1, pp. 59–103. For the mundane egg or mundane shell, see Damon, S. Foster, *A Blake Dictionary*, Providence, R.I., 1965, pp. 287–89.

I am, like others, Just Equal in Invention & in Execution as my works shew. I, in my own defence, Challenge a Competition with the finest Engravings & defy the most critical judge to make the Comparison Honestly, asserting in my own Defence that This Print is the Finest that has been done or is likely to be done in England, where drawing, its foundation, is Contemn'd, and absurd Nonsense about dots & Lozenges & Clean Strokes made to occupy the attention to the Neglect of all real Art. I defy any Man to Cut Cleaner Strokes than I do, or rougher where I please, & assert that he who thinks he can Engrave, or Paint either, without being a Master of drawing, is a Fool. Painting is drawing on Canvas, & Engraving is drawing on Copper, & nothing Else. Drawing is Execution, & nothing Else, & he who draws best must be the best Artist; to this I subscribe my name as a Public Duty.[16]

Despite this general contempt for the dot and lozenge technique, the firmness of Basire's method affected Blake so profoundly that he could not bear the least fuzziness of outline, and always demanded from what he considered the best art—from all visual art, not just from engraving—that it should be dominated by what he called 'the bounding line':

The great and golden rule of art, as well as of life, is this: That the more distinct, sharp, and wiery the bounding line, the more perfect the work of art; and the less keen and sharp, the greater is the evidence of weak imitation, plagiarism, and bungling. Great inventors, in all ages, knew this: Protogenes and Apelles knew each other by this line. Rafael and Michael Angelo and Albert Dürer are known by this and this alone. The want of this determinate and bounding form evidences the want of idea in the artist's mind, and the pretence of the plagiary in all its branches. How do we distinguish the oak from the beech, the horse from the ox, but by the bounding outline? How do we distinguish one face or countenance from another, but by the bounding line and its infinite inflexions and movements? What is it that builds a house and plants a garden, but the definite and determinate? What is it that distinguishes honesty from knavery, but the hard and wiery line of rectitude and certainty in the actions and intentions? Leave out this line, and you leave out life itself; all is chaos again, and the line of the almighty must be drawn out upon it before man or beast can exist. Talk no more then of Correggio, or Rembrandt, or any other of those plagiaries of Venice or Flanders. They

16. K.602.

were but the lame imitators of lines drawn by their predecessors, and
their works prove themselves contemptible, dis-arranged imitations,
and blundering, misapplied copies.[17]

The word 'bounding' has two distinct meanings, and I do not
think that there is much doubt that Blake's use of it embraced both.
The first meaning is here more apparent; to quote Websters's *New
International Dictionary*, Third Edition, it is 'the external or limiting
line of an object, space or area'. The second meaning, although not
so apparent in Blake's context, provides a vivid description of the
quality of Blake's linear compositions: 'a leap or spring usually made
easily or lightly'.

Each of these qualities is apparent in the majority of Blake's engraved
work. To take an example at random, they may be seen to perfection
in plate 14 of *Illustrations of the Book of Job*, with everything within
the main design and the border precisely defined by firm outlines
(Plate 5). At the same time those outlines move about the design,
imparting to the whole composition, despite its austerity, that sensitive,
vital, 'dancing' quality that is evident in so much of Blake's work.
It is perhaps not without significance that the *Job* illustrations were
used in the 1930s as a basis for a successful ballet.[18]

To my mind this aspect of Blake's bounding line is at least as impor-
tant as its 'limiting' or 'outlining' function. This is even more apparent
when we consider Blake's views on the limits or boundaries placed on
man by the Elohim, in the personification of Urizen,[19] in the act of
creation, so vividly illustrated in his great design for the frontispiece
of his prophetic book *Europe*[20] (Plate 61), which shows Urizen as a
naked bearded figure reaching down from an orb (the sun?) and
placing the points of a compass into the void, to limit the bounds of
the spirit of man who, by this limiting act of the Creator, has fallen
from his high state of unlimited imagination:

> He form'd a line & a plummet
> To divide the Abyss beneath;
> He form'd a dividing rule;
> He formed scales to weigh,

17. *A Descriptive Catalogue*, K.585. 18. Keynes, *Blake Studies*, Chapter XXIV.
19. Damon, *Blake Dictionary*, pp. 419–24.
20. This is a relief-etching. See Chapter 5.

He formed massy weights;
He formed a brazen quadrant;
He formed golden compasses,
and began to explore the Abyss.[21]

The apparent contradiction, that Blake approved of definition in his visual work, yet disapproved of bounded limits in man's spiritual life, may to some extent be explained by a passage in another of his mythopoeic sequences, *The Book of Los* (Los being the imaginative faculty).[22] This is Blake's version of Genesis, and its climax is the creation of Adam, 'a Human Illusion', which results from Los's efforts to escape from the cold intellectual power of Urizen, and to assume shape and form, simultaneously creating light and the Sun, to which he binds Urizen, forcing him, too, to assume form:

 . . . the Sun
Stood self-balanc'd. And Los smil'd with joy.
He the vast Spine of Urizen siez'd,
And bound down to the glowing illusion.

But no light! for the Deep fled away
On all sides, and left an unform'd
Dark vacuity: here Urizen lay
In fierce torments on his glowing bed;

Till his Brain in a rock & his Heart
In a fleshy slough formed four rivers
Obscuring the immense Orb of fire
Flowing down into night: till a Form
Was completed, a Human Illusion
In darkness and deep clouds involv'd.[23]

In other words, Los forces a shape on Urizen in order to define error, and by so doing enables himself to overcome it. It is not, I think, too far fetched to see this as one of the attributes of Blake's bounding line—it *defines* at once what the artist is trying to show (which may not necessarily be error, but any idea), without risk of

21. *The First Book of Urizen*, K.233–34. 22. Damon, op. cit., pp. 246–53.
23. K.260. The four rivers in this passage symbolise the four fallen senses.

blurring his message.²⁴ While he hated limitation, Blake hated indefiniteness above all other things.

Blake's views on the bounding line, although characteristically expressed, were not entirely original. His friend John Flaxman was one of the chief exponents of firm and brilliant outline in such works as his illustrations to the *Odyssey*, the *Iliad*, the *Theogony* of Hesiod, and the works of Dante. Blake engraved some of these, and came under their influence²⁵ (Plates 13 and 15).

Again, Blake's friend, George Cumberland, published *Thoughts on Outline* (1796) and *Outlines from the Ancients* (1829), which emphasised the value of the bounding line. For example in *Outlines from the Ancients*, Cumberland says: '[Outlines] . . . convey to the mind all that ever an artist finds useful . . . they contain all that was in the mind of the composer as far as invention and composition extend. . . . He who can barely delineate a *correct outline* of any object that is placed before him is far advanced in the arts, whilst he that is incapable of it, may be . . . called a painter, but can never deserve to rank as an artist . . .' And, in a passage preceding plates by Blake in the same work he remarks: 'The four following plates, from compositions by the author, outlined by *Blake*, are given as an examplification of the principles laid down on the *Thoughts in Outline*, and in the work; that of lines flowing towards lines so as to produce a harmony by confining the eye to the object.'²⁶ All of which is close to Blake's claim 'That the more distinct, sharp, and wiry the bounding line, the more perfect the work of art.'

To Blake, even colour had to take second place to outline. 'All', he wrote, 'depends on Form or Outline, on where that is put; where that is wrong, the Colouring never can be right.'²⁷ Again, 'the disposition of forms always directs colouring in works of true art'.²⁸ Elsewhere, he asks, 'What kind of Intellects must he have who sees only the Colours of things & not the Forms of Things?'²⁹

Blake was still obsessed by the bounding line during his last years,

24. Some have seen the influence of the bounding line, even in Blake's poetry. Consideration of this is beyond the scope of this book, but it is the subject of an unpublished dissertation by Margaret Shook, *Visionary Forms: Blake's Prophetic Art and the Pictorial Tradition* (University of California, Berkeley, 1966). Cf. Paley and Phillips (eds), *William Blake*, Oxford, 1973, p. 91.

25. Blunt, *Art of William Blake*, pp. ix, 40, 42, 90.

26. *Outlines from the Ancients*, pp. ix, x, [45]. 27. *Descriptive Catalogue*, K.563–64.

28. Ibid., K.580–81. 29. *Public Address*, K.597.

not only in his engraved work, but in every facet of his art and thought. In a letter to George Cumberland, written on 12 April 1827, four months before his death, he says:

> For a Line or Lineament is not formed by Chance: a Line is a Line in its Minutest Subdivisions: Strait or Crooked It is Itself & Not Intermeasurable with or by any Thing Else. Such is Job, but since the French Revolution Englishmen are all Intermeasurable One by Another, Certainly a happy state of Agreement to which I for One do not Agree. God keep me from the Divinity of Yes & No too, The Yea Nay Creeping Jesus, from supposing Up & Down to be the same Thing as all Experimentalists must suppose.[30]

But let us return to the practical aspects of Blake's technique as an engraver, and we will begin by considering his copper plates, a number of which still exist. Many of these were supplied by the well-known firm of Pontifex, and it is of interest to note in passing that they also supplied plates to Blake's contemporary, Goya.[31] Many of Blake's surviving plates are stamped with their name, although it varies somewhat: for instance, I Pontifex & Co., 22 Lisle Street, Soho, London, and Jones & Pontifex, 47 Shoe Lane, London. One plate exists with the stamp, G. Harris, No. 31 Shoe Lane, London, so it is apparent that Blake did not deal exclusively with Pontifex.[32]

An interesting fact which emerges from a study of these plates is that they show that Blake sometimes used second-hand plates, and also cut up his own original plates for re-use, doubtless to save expense. At least two of the *Job* plates were engraved on the backs of sixty-year-old plates which had been used by a previous engraver for making illustrations for a work by du Hamel du Monceau: *Practical Treatise of Husbandry* (1762).[33] In fact it has been known for many years that Blake re-used plates, for in 1845 John Thomas Smith wrote that he often took 'very few impressions from the plates before they were rubbed out to enable him to use them for other subjects'.[34]

The engraver's main tool, and therefore Blake's, is the burin (Figure

30. K.878. 31. Hayter, op. cit., p. 199.
32. Keynes, *Blake Studies*, p. 123; Bentley, G. E., junr., 'Blake's *Job* Copperplates', *The Library*.
33. Bentley, loc. cit.
34. *A Book for a Rainy Day*, London, 1845, p. 82n., cf. Gilchrist, p. 2.

1). For engraving, the copper plate was balanced against a pad or cushion filled with sand, so that it could be easily turned while working. The top of the handle of the burin was held in the palm, with the index finger held along the blade to guide it, while the upper part of the blade and the lower part of the handle were lightly gripped between the thumb and remaining three fingers.

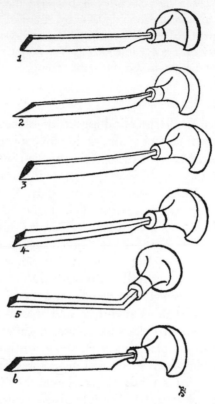

Figure 1. Engraving Tools.

1 ROUNDED SCORPER Rounded cutting edge. Used for making dotted stipples and for clearing spaces.

2. TINT TOOL Triangular cutting face. Used for making straight lines (particularly parallel lines) and outlines, and for giving 'tints' or textures. It can, in this way, be used to add a 'painterly' quality to an engraving.

3. SPITSTICK Triangular cutting face, with curved sides. Used particularly for making curved lines

	and for fine stippling. Much used by reproductive engravers like the Dalziels because of its versatility, which is largely made possible by its curved sides.
4. BURIN or GRAVER	Diamond-shaped cutting face. The most important engraving tool. Used for almost anything, but especially for stippling. Bewick used it almost exclusively.[1]
5. BURIN or GRAVER for LINE-ENGRAVING	
6. SQUARE SCORPER or CHISEL	Square cutting face. Used for making chisel cuts and wide lines. Also used for clearing spaces.

These tools may be used for many more purposes than those stated, which are but general indications.

[1] *The Woodcut*, No. II, p. 28 (London, 1928).

To engrave a line, the point of the burin was pressed into the surface of the copper, but at the same time, and with about the same amount of pressure, the plate was pressed against the burin. It was necessary to keep the burin very sharp, and this was done by rubbing it on an oiled whetstone.

When a line had been engraved a small burr ran along each side of the groove. It was the practice to remove this as it tended to make the lines too rich and to diminish their sharp brilliance. It also ensured that large editions could be run off without showing any appreciable difference. The burr, if allowed to remain, would in time have been worn away and there would have been a considerable difference in the quality of the prints before it had worn, while it was wearing, and after it had gone.

Briefly, prints are made from an engraved plate by warming the plate and then inking it, wiping the ink away from the surface, but allowing it to remain in the engraved lines, and then applying a sheet of damp paper to it under pressure, in a printing press. This forces the paper into the grooves, so that the ink is transferred to it.

This was the way in which Blake would have worked. A few more intimate details are filled in by a note and a sketch plan of Blake's apartment in 3 Fountain Court, Strand, made by Blake's friend. George Richmond, in his copy of Gilchrist's *Life of Blake*:

The fire-place was in the far right-hand corner opposite the window; their bed in the left hand, facing the river; a long engraver's table stood under the window (where I watched Blake engrave the *Book of Job*. He worked facing the light), a pile of port-folios and drawings on Blake's right near the only cupboard and on the poet-artist's left—a pile of books placed flatly on one another; no bookcase.[35]

Blake's method of transferring the design from the original drawing to the plate appears to have varied somewhat. In some cases he squared the original drawing for transfer to the plate;[36] that is to say, the drawing was covered with parallel lines both horizontally and vertically, forming small squares, so that the design could be accurately copied, portion by portion, into similar squares drawn on the plate.[37]

In one of his letters[38] Blake describes the treatment of the surface of the copper plate so as to allow the transfer to be made:

Take a cake of Virgin's Wax[39] (I don't know what animal produces it) & stroke it regularly over the surface of a warm Plate (the Plate must be warm enough to melt the Wax as it passes over), then immediately draw a feather over it & you will get an even surface which, when cold, will recieve any impression minutely.

NOTE: The danger is in not covering the Plate *all over*.

Blake goes into this in greater detail in a memorandum in a note-book written in 1807, except that here he writes of engraving on pewter instead of on copper:

To Engrave on Pewter: Let there be first a drawing made correctly with black lead pencil: let nothing be to seek; then rub it off on the plate cover'd with white wax, or perhaps pass it thro' press—this will produce certain & determin'd forms on the plate & time will not be wasted in seeking them afterwards.[40]

35. Bentley, G. E. Jr, 'William Blake, Samuel Palmer, and George Richmond', *Blake Studies*, Vol. 2, No. 2, 1970, p. 44.

36. Keynes, *Blake Studies*, p. 146.

37. Cf. Butlin, Martin, 'William Blake in the Herbert P. Horne Collection', *Blake Newsletter*, VI, pp. 19–21.

38. To George Cumberland, K.790.

39. Purified bees' wax or candle wax.

40. K.440.

But Blake did not always transfer a design so laboriously, and seems in some cases at least to have composed a great deal with the burin on the plate itself. Nor was this the case only with his own designs, but also with the work of other artists. For example, in a number of engravings after John Henry Fuseli, if Fuseli's original work is compared with Blake's finished engravings, it is obvious that extensive areas of the designs are by Blake. Fuseli was sixteen years older than Blake, and it demonstrates what considerable confidence he had in the younger man's work to allow him to do this. It is interesting to note that in one of these examples, the frontispiece to Lavater's *Aphorisms on Man* (1788), Blake did not even trouble to reverse Fuseli's design, but copied it on to the plate just as it appeared, so that the engraving shows, so to speak, a mirror image of the design (Plate 6). But even where the design is conventionally engraved in reverse, as in the portrait of Michelangelo in Fuseli's *Lectures* (1801), the details of the design are much elaborated by Blake (Plate 7).[41]

But Blake's relationship with Fuseli was, for a period at least, especially cordial Blake wrote of Fuseli:

> The only Man that e'er I knew
> Who did not make me almost spew
> Was Fuseli: he was both Turk & Jew—
> And so, dear Christian Friends, how do you do.[42]

Some other artists were not so accommodating with their engraver, and there is, for instance, no evidence that he was given such freedom by John Flaxman, Thomas Stothard, or George Cumberland, many of whose designs he engraved. It was perhaps with such comparatively insensitive patronage in mind that he wrote another rhyme:

> Give pensions to the Learned Pig
> Or the Hare playing on a Tabor;
> Anglus can never see Perfection
> But in the Journeyman's Labour.[43]

Working like most of his contemporaries, as a preliminary to the actual engraving of the plates, Blake usually etched in the main outlines, or at least the background. Such practice had been established

41. Cf. Todd, Ruthven, 'Two Blake Prints and Two Fuseli Drawings', *Blake Newsletter*, V, pp. 173–81. 42. K.551. 43. K.548.

as early as the time of Lucas van Leyden (1494–1533). In some cases, Fuseli (and perhaps other artists) might have marked out their designs by etching the plate, which would then have been sent to Blake to be engraved.[44]

Usually, in illustrations made in Blake's day, the background was etched and the figures engraved (Plate 8). This was the 'mixed method' used by Blake's master, Basire, and one in which Blake would have become familiar during his apprenticeship. Proofs exist which show that this was Blake's method of proceeding. An example is shown in Plate 9, a proof of an illustration in William Hayley's *Ballads* (1805), in which it will be seen that the background is completed, the figures and the horse only partly so, although most of the details which may be seen in these are probably also etched. A comparison of the completed engraving in Plate 10 will reveal that such details as the child's and woman's heads and faces and figures, and the horse, have been given greater detail and more accentuated moulding. This was accomplished by burin work, texture and shading being suggested by the thickness and frequency of the lines. It is a typical example of how Blake divided his work between etching needle and burin.

In etching, the plate is covered with a ground resistant to acid. This is then smoked to darken it, lines are scratched through it with an etching needle, and these show up brightly against the smoked ground. After this, the plate is immersed in a bath of acid, the acid biting into the exposed lines. When the design is completed, the ground is removed, and prints are made in the same way as from an engraved plate. It is possible that Blake used the wax ground described on page 16, not only to receive a transfer of the design, but also as an etching ground.

Many of Blake's plates contained more etched than engraved lines.[45] This was something he had in common with many of his contemporaries. One authority has claimed that a large number of Blake's 'engraved' plates were etched exclusively,[46] and there is much evidence in the quality of the lines on the prints, to support this. Plates 11 and 12 will illustrate the difference. In Plate 12 the lines on the figure are

44. Schiff, Gert, *Catalogue Raisonné of the Work of Fuseli*, quoted by R. Todd, *Blake Newsletter*, V, p. 179.
45. Easson and Essick, *William Blake Book Illustrator*, Vol. I, p. viii.
46. Bentley, *Landon K. Thorne Catalogue*, p. 56.

hard, clearly cut and of variable width, swelling and diminishing as required; they could have been cut only by a burin. In Plate 11 they are wavy, and too closely twisted to have been cut by a burin; they are typical of work scratched with a needle and bitten with acid.

A further comparison may be made with the detail in one of Blake's relief-etchings (Plate 56), which we shall be fully considering in Chapter 5. Although relief-etching is a different process from conventional etching, the same quality of line is apparent in both, quite different from the infinitely variable line cut into the plate's surface with a burin.

Rembrandt sometimes sharpened lines in his etchings with a burin, and indeed many engravers (and Blake was one of them) made a practice of using some of their etched lines as guides for their burins, the burin being inserted into the etched groove, so that the line was given an engraved finish, before the removal of the ground from the plate. For this reason alone, one should be cautious of ascribing the technique of a print on the grounds of appearance. A resourceful engraver can achieve all kinds of effects that could be mistaken for etching or aquatint or related techniques. For example, tones may be made on an engraving by hammering or tapping dots into the surface of the plate, which will print just as well as etched tones. Similarly, a wood engraver can imitate the cross hatching of engraving by using two blocks, one to print one set of lines, the other to be superimposed on the first print for the crossing lines. But, so far as I am aware, Blake did not use such imitations.

An interesting contrast between the engraving style of Blake and that of another artist may be made if we compare Blake's engravings of Flaxman's designs for the *Iliad* with those made by the Italian artist Thomas Piroli for the same work at about the same time (Plates 13 and 14). As Gilchrist put it: 'Blake's work is like a drawing, with traces of a pen; Piroli's is the orthodox copperplate style.'[47] The freedom of Blake's work is accounted for, at least in part, by his extensive use of etching. Yet in his later work Blake used etching less.

In some cases the labour of producing illustrations was divided between two, three or more craftsmen, and it is probable that many of Blake's journeyman engravings were produced in this way, with one artist perhaps making the etched background and border or

47. Gilchrist, p. 96.

frame (if there was one), and another (in this case Blake) engraving the figures and carrying out any other burin work.

A variant of his etching technique was mentioned by Blake in a letter written on 23 August 1799.[48] He writes of 'Chalk Engraving', which was, he said, 'at least six times as laborious as Aqua tinta'. Here Blake was referring to the chalk line, a crayon method of etching, which involved the use of the roulette, a tool consisting of a small wheel, with dots around its perimeter, revolving in a handle. To make a print in imitation of a chalk line, the drawing is first transferred to the prepared copper, and then different roulettes are passed along the lines, up and down. Following this, the lines are worked over with a mattoir (a coarse punch for making a rough or matt surface) and point graver, removing the ground as would be done with an etching needle. Afterwards the plate is bitten and printed like an ordinary etching. The print, which is often in red (sanguine), looks like a chalk drawing.

The process, which was superseded by the easier process of lithography, was invented about 1740 by Jean C. François. It was much used by such engravers as Bartolozzi, and was very popular from the 1770s onwards, so that it is not surprising to find Blake using it for commercial work. Some examples of Blake's use of this technique occur in illustrations for *A Proposition for a New Order in Architecture* by Henry Emlyn (1781) and *The Theogony Works and Days and the Days of Hesiod* by John Flaxman (1817) (Plate 15).

Blake was a tremendously energetic worker, a fact that is illustrated by the progress of the plates he engraved for the edition of Edward Young's *Night Thoughts* for the bookseller Richard Edwards of New Bond Street, London. According to Gilchrist, he engraved forty-three large folio plates in a year (Plate 16);[49] in fact the dates of the copper plates range between 21 June 1796 and 22 March 1797.[50]

The *Night Thoughts* engravings are not among Blake's most brilliant work. For one thing, their format, as borders surrounding a central text, is not promising. For another, Blake seems to have become somewhat bored with the project, so that even the energetic bounding line of his best engraved work is reduced to something approaching monotony.

These engravings are much improved by being coloured, and a

48. To Dr John Trusler, K.794. 49. Gilchrist, p. 116.
50. Keynes, *Blake Studies*, p. 53.

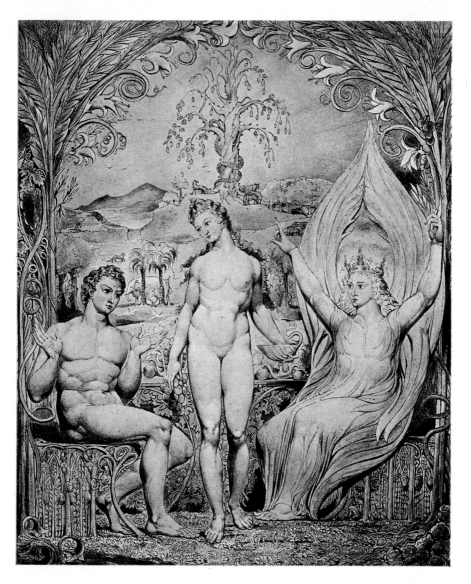

I Raphael Conversing with Adam, from the *Paradise Lost*
series. Water-colour. 19¼ by 15⅝ ins. *Boston Museum of Fine Arts,
Boston, Mass.*

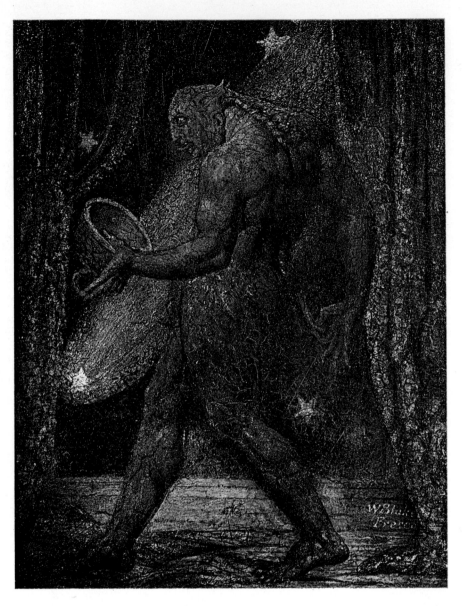

II The Ghost of a Flea, *c.* 1819. Tempera on panel. 8¾ by 6⅜ ins.
Tate Gallery

number of copies were issued, painted in water-colour washes, which
were applied before the printed sheets of the book were folded and
bound, although it is doubtful if Blake himself coloured every set;
it is more likely that he provided a master specimen for the printer's
own professional colourists to copy, as would have been the usual
practice. Perhaps the colouring was done by Richard Edwards's
brother, Thomas, who was skilled both at this work and as a fore-
edge painter.

Some twenty coloured copies are known out of a total edition of
perhaps two hundred;[51] so much improved are the coloured copies
over the somewhat bare and austere uncoloured ones, that it is possible
that Blake intended from the start that all copies should be coloured.

Yet this might not be so, for Blake coloured other engravings which
have strength and brilliance in their uncoloured state. For instance, a
beautifully tinted impression of his great *Canterbury Pilgrims* plate is
known,[52] also a coloured set of Illustrations of *The Book of Job*.[53] In
one sense this added colour is a contradiction, for it tends, especially
in cases where Blake applied opaque pigments, to obscure his bounding
line. Yet Blake himself did not necessarily see his colour in this way:

> The Venetian and Flemish practice is broken lines, broken masses, and
> broken colours. Mr. B.'s practice is unbroken lines, unbroken masses,
> and unbroken colours. Their art is to lose form; his art is to find form,
> and to keep it.[54]

Certainly in the coloured copies of *Night Thoughts*, Blake's colour
helped him to achieve this aim of 'unbroken masses'. The fact that
some of his coloured engravings fell short of his intentions does not
alter the energetic force of Blake's thought.

In some of his journeyman engravings—for example in *Zephyrus
and Flora*, *Evening Amusement*, *Mrs Q*, and *The Fall of Rosamund*
(Plates 17 and 18)—colour was applied quite differently. Coloured
impressions of these (monochrome impressions are known also)
were actually printed in colour. The various coloured printing inks

51. Moss, W. E., 'The Coloured Copies of Blake's "Night-Thoughts"'; Bentley,
G. E., Jr, 'A Census of Coloured Copies of Young's *Night Thoughts*' (1797); *Blake
Newsletter*, II, pp. 19–23, 41–45. A description of the method used in colouring
engravings is given in Chapter 5, pp. 74–82.
52. Collection of Sir Geoffrey Keynes.
53. Grant, John E., 'Blake's "Illustrations of The Book of Job"', *Times Literary
Supplement*, 30 November 1973, p. 1484.
54. *A Descriptive Catalogue*, K.573.

C

were applied to the surface of the plate with a dabber of cloth or leather (known as a *poupée*), and the whole polychrome surface was printed in a single operation. This is known as printing *à la poupée*.

The four examples I have just quoted were conceived in another technique used by Blake—stipple—although *The Fall of Rosamund* is partly line-engraved. Stipple, which is really a form of etching, consists of covering the plate with etching ground, composing the design with numerous dots made through the ground with a point, and then biting it in with acid like an ordinary etching. The smooth and soft surface imparted by this technique makes it eminently suitable for the reproduction of water-colours, and indeed this was one of its principal applications.

Blake never used pure stipple for his visionary work, reserving it mainly for reproductive work; it is evident that he considered such a technique in its unadulterated form, unsuitable to 'display [his] Giant forms to the Public'.[55] But there was a demand for it at the time, he was a professional engraver and had almost certainly learnt or picked up the technique during his apprenticeship, and he was prepared to give publishers and the public what they demanded, even if the trouble he had to take was infinite. 'To Engrave after another Painter', he wrote, 'is infinitely more laborious than to Engrave one's own Inventions. . . . I have no objection to Engraving after another Artist. Engraving is the profession I was apprenticed to, & should never have attempted to live by any thing else, If orders had not come in for my Designs & Paintings'.[56]

During his lifetime, Blake engraved over three hundred and eighty commercial plates. They provided his main source of income, and he was still producing them in the last years of his life.

One writer has discerned in the difference of technique between Blake's commercial and visionary engraved work, signs of a psychological release from 'the rational, mechanical mills of reproductive engraving', and cites the difference between *Joseph of Arimathea Among the Rocks of Albion* and *The Dance of Albion* (Plates 2 and 19): the former overlaid with the net of the abstract and disguising dot and lozenge method, the latter, while maintaining the hard, wiry, bounding line, showing infinitely greater freedom of expression, developed perhaps under the influence of the freer method used by

55. *Jerusalem*, K.620. 56. Letter to Dr Trusler, K.794.

such engravers as James Barry, John Hamilton Mortimer, and James Gillray.[57]

There is much truth in that, but even in *The Dance of Albion* it is obvious that Blake's training had been in the traditional school epitomised by Basire, for the lines indicating the sky are engraved in a manner as conventional as dot and lozenge, and moreover appear to have been ruled, as in commercial work. Such work as the illustrations to *Night Thoughts* shows even more clearly that Blake was prepared to make use of engraving conventions. It was near the end of his life that Blake almost completely discarded convention, to achieve his greatest expression in engraved work, in *Job*. Here are no ruled lines, and only a bare minimum of dot and lozenge on one or two plates. Everything is conceived with freedom, the burin predominating, but subtly wedded here and there to passages in stipple and etching (Plates 5 and 20).

A stage on the way to the realisation of this synthesis of techniques is dramatically illustrated in the two states of the plate 'Mirth', each known in only one impression (Plates 64 and 65). The earlier state, realised in a mixture of chalk engraving and stipple is elegant and delicate, suggesting, as these media did so well, the character of the water-colour from which it was taken. But Blake subsequently rubbed down most of the copper and almost completely re-engraved the subject, creating a work of art in its own right, strong, firm and decisive. Yet a certain amount of stippling was allowed to remain in the foreground and in the distant trees. There seems little doubt that Blake discerned in this state of the plate a demonstration of the possibilities of combining techniques that were to result in *Job*.

Gilchrist pointed out Blake's indebtedness in *Job* to Dürer, Marcantonio Raimondi, and Bonasone. 'From Bonasone, especially', he wrote, 'Blake gleaned much, and was led, on first becoming familiar with his work, to express a regret that he had been trained in the Basire school, wherein he had learned to work as a mere engraver, cross-hatching freely. He now became an artist, making every line tell. The results of this change of style are manifest in the engraved *Illustrations of Job*. In them, too, Bonasone's plan was adopted, of working wholly with the graver and etching nothing.'[58]

Gilchrist is wrong in saying that Blake worked on *Job* with the

57. Essick, 'Blake and the Traditions of Reproductive Engraving'.
58. Gilchrist, p. 289.

graver alone, for, as I have just said, there is a certain amount of subtle stipple and etching. At the same time there remains much of the austere, old-fashioned, dry and sharp-lined methods used in Basire's studio. This is even more apparent in the seven unfinished Dante engravings on which Blake was working just before his death (Plate 21). Being unfinished, it would be unfair to compare these with the *Job* illustrations, but if Blake had lived to complete them, the Dante engravings might have shown a further development of technique even beyond the Job plates.

Another of Blake's mentors in engraving was James Fittler, A.R.A. (1758–1835), said by Samuel Redgrave to have 'worked in the line manner; was powerful in light and shade, hard and not agreeable in manner'.[59] This hard linear style appealed strongly to Blake, and must have reminded him of work turned out from the Basire *atelier*. To William Hayley on 4 May 1804, he wrote of 'the admirable prints to [William Falconer's *The Shipwreck*] by Fittler. Whether you intended it or not, they have given me some excellent hints in engraving; his manner of working is what I shall endeavour to adopt in many points.'[60] Archibald G. B. Russell, writing in 1912, said he could see some traces of Fittler's method of engraving in Blake's plate of 'Sketch of a Shipwreck after Romney' in Hayley's *Life of George Romney* (1809).[61] The handling of this plate is certainly reminiscent of Basire's work, and contains many passages in dot and lozenge.

In his *Public Address*, written in his Note-book about 1810, Blake pours scorn on the smooth tonal conventions of Woollet and Strange, two contemporary engravers, and comes down firmly in favour of his old master, Basire. He is writing of his engraving of *The Canterbury Pilgrims*:

In this Plate Mr B. has resumed the style with which he set out in life, of which Heath & Stothard were the awkward imitators at that time; it is the style of Alb. Durer's Histories & the old Engravers, which cannot be imitated by any one who does not understand drawing, & which, according to Heath & Stothard, Flaxman, & even Romney, spoils an Engraver; for Each of these Men have repeatedly asserted this Absurdity to me in Condemnation of my Work & approbation of Heath's lame

59. *A Dictionary of Painters of the English School*, London, 1878, p. 153.
60. K.843.
61. *The Engravings of William Blake*, London, 1912, pp. 178–79.

imitation, Stothard being such a fool as to suppose that his blundering blurs can be made out & delineated by any Engraver who knows how to cut dots & lozenges equally well with those little prints which I engraved after him five & twenty years ago & by which he got his reputation as a draughtsman. . . .

A certain Portrait Painter said To me in a boasting way, 'Since I have Practised Painting I have lost all idea of drawing.' Such a Man must know that I look'd upon him with contempt; he did not care for this any more than West did, who hesitated & equivocated with me upon the same subject, at which time he asserted that Woolett's Prints were superior to Basire's because they had more Labour & Care; now this is contrary to the truth. Woolett did not know how to put so much labour into a head or a foot as Basire did; he did not know how to draw the Leaf of a tree; all his study was clean strokes & mossy tints—how then should he be able to make use of either Labour or Care, unless the Labour & Care of Imbecillity? The Life's Labour of Mental Weakness scarcely Equals one Hour of the Labour of Ordinary Capacity, like the full Gallop of the Gouty Man to the ordinary walk of youth & health. I allow that there is such a thing as high finish'd Ignorance, as there may be a fool or a knave in an Embroider'd Coat; but I say that the Embroidery of the Ignorant finisher is not like a Coat made by another, but is an Emanation from Ignorance itself, & its finishing is like its master—The Life's Labour of Five Hundred Idiots, for he never does the Work Himself.

What is Call'd the English Style of Engraving, such as proceeded from the Toilettes of Woolett & Strange (for theirs were Fribble's Toilettes) can never produce Character & Expression. I knew the Men intimately, from their Intimacy with Basire, my Master, & knew them both to be heavy lumps of Cunning & Ignorance, as their works shew to all the Continent, who Laugh at the Contemptible Pretences of Englishmen to Improve Art before they even know the first Beginnings of Art. I hope this Print will redeem my Country from this Coxcomb situation & shew that it is only some Englishmen, and not All, who are thus ridiculous in their Pretences. Advertisements in Newspapers are no proof of Popular approbation, but often the Contrary. A Man who Pretends to Improve Fine Art does not know what Fine Art is. Ye English Engravers must come down from your high flights; ye must condescend to study Marc Antonio & Albert Durer. Ye must begin before you attempt to finish or improve, & when you have begun you will know better than to think of improving what cannot be improv'd. It is very true, what you have said for these thirty two Years. I am Mad or Else you are so; both of us cannot be in our right senses. Posterity will judge by our Works. Woolett's & Strange's works are like those of Titian & Correggio: the Life's Labour

of Ignorant Journeymen, Suited to the Purposes of Commerce no doubt, for Commerce Cannot endure Individual Merit; its insatiable Maw must be fed by What all can do Equally well; at least it is so in England, as I have found to my Cost these Forty Years. . . .

Wooletts best works were Etch'd by Jack Brown. Woolett Etch'd very bad himself. Strange's Prints were, when I knew him, all done by Aliamet & his french journeymen whose names I forget.

"The Cottagers," & "Jocund Peasants," the "Views in Kew Gardens," "Foots Cray", & "Diana," & "Acteon," & in short all that are Call'd Woolett's were Etch'd by Jack Browne, & in Woolett's works the Etching is All, tho' even in these, a single leaf of a tree is never correct.

Such Prints as Woolett & Strange produc'd will do for those who choose to purchase the Life's labour of Ignorance & Imbecillity, in Preference to the Inspired Moments of Genius & Animation.[62]

This outburst was caused by the cavalier treatment of Blake by the publisher and engraver Robert Hartley Cromek, who commissioned from him a series of designs to illustrate Robert Blair's poem, *The Grave*. Blake wrote of this in a letter to William Hayley, written on 27 November 1805:

Mr Cromek the Engraver came to me desiring to have some of my Designs; he nam'd his Price & wish'd me to Produce him Illustrations of The Grave, A Poem by Robert Blair; in consequence of this I produced about twenty Designs which pleas'd so well that he, with the same liberality with which he set me about the Drawings, has now set me to Engrave them. He means to Publish them by Subscription with the Poem as you will see in the Prospectus which he sends you in the same Pacquet with the Letter. You will, I know, feel as you always do on such occasions, not only warm wishes to promote the Spirited Exertions of my Friend Cromek.[63]

In the event, only twelve of the designs were made and for these Cromek paid Blake 20 guineas. As Gilchrist remarked, 'for twelve of the most original designs of the century . . . [this] was no bad beginning'.[64] Blake had hoped to make more by executing the engravings, but through Cromek's double-dealing, the commission for this part of the work was given to Louis Schiavonetti, an Italian pupil of Bartolozzi, and an exponent of a smooth and highly-finished style

62. K.592–94. 63. K.861. 64. Gilchrist, p. 218.

of engraving which Cromek no doubt felt would meet with a better response from the public than Blake's hard, dry style. Cromek's assumption is borne out to some extent by a passage in a letter concerning the Job illustrations written on 22 April 1830 to John Linnell by the Quaker poet, Bernard Barton. 'There is', he wrote, 'a dryness and hardness in Blake's manner of engraving which is very apt to be repulsive to print-collectors in general—to any, indeed, who have not taste enough to appreciate the force and originality of his conceptions, in spite of the manner in which he has embodied them. I candidly own I am not surprised at this; his style is little calculated to take with the admirers of modern engraving. It puts me in mind of some old prints I have seen, and seems to combine somewhat of old Albert Dürer with Bolswert. I cannot but wish he could have clothed his imaginative creations in a garb more attractive to ordinary mortals, or else given simple outlines of them. The extreme beauty, elegance, and grace of several of his marginal accompaniments induce me to think that they would have pleased more generally in that state. But his was not a mind to dictate to; and what he has done is quite enough to stamp him as a genius of the highest order.'[65]

In time, Blake acquired a large amount of engraving equipment, so much that when, in 1800, he left London to live for a time at Felpham in Sussex, sixteen heavy boxes were required to transport it there.[66] In addition to copper plates, paper and much else, these boxes would have contained Blake's press, which, if it was the same one that he possessed at the end of his life, and Blake could hardly have afforded a replacement, was quite large.

We know a little about it, as it was taken after Blake's death to the Cirencester Place house of his friend, John Linnell, where Mrs Blake stayed for a time. Mrs Blake still used the press to print impressions from some of Blake's plates for his illuminated books, but she found it was too large for her, and Linnell tried to persuade James Lahee, a prominent member of the engraving trade, to exchange it for a smaller one. From Lahee's reply we learn that it was probably constructed of wood, and he says that 'if it is Grand Eagle' he would perhaps be able to make an exchange. Sir Geoffrey Keynes has pointed out that 'Grand Eagle' refers to a size of paper measuring 40 by 27 inches. As the size of a press was indicated by the width of its rollers, this

65. Story, Alfred T., *The Life of John Linnell*, London, 1892, Vol. I, pp. 176–77.
66. Keynes, *Blake Studies*, p. 105.

would indicate a roller width of forty inches. One of less than half that width would have been adequate for Mrs Blake.[67]

Plate 22 illustrates the probable kind of press used by Blake. The rollers on this, and possibly on Blake's, are made of the West Indian wood, *lignum vitae*, the hardest wood in existence, so hard and dense that its specific gravity is higher than that of water, so that, unlike other woods, it will not float. It is therefore eminently suitable for use as press rollers, which must be as hard and rigid as possible.

<p style="text-align:center">* * *</p>

Blake's engraving and etching methods did not exhaust his graphic techniques. About 1807 he made his only lithograph, *Enoch* (Plate 23).

The technique of lithography (or polyautography as it was at first called) had been discovered in 1796 by Aloys Senefelder, a Bavarian. It is the only major graphic process, until the invention of modern photographic processes, whose inventor's name is known to us. The method, which is based on the antagonism of water to grease, is entirely planographic. The printing surface is usually stone, but metal, especially zinc with a granulated surface, is sometimes used. This surface is made chemically clean so as to be very sensitive to grease, and the design is drawn on it with greasy lithographic ink ('tusche') or chalk. Sometimes, if ink is used, the design is drawn with a pen; this is doubtless how Blake drew *Enoch*. Then those parts of the surface bearing no drawn lines or areas are desensitised by the application of dilute nitric acid and gum arabic. The stone is moistened, an inked roller is drawn over it, and the ink adheres to the dry, drawn parts, but not to the wet, desensitised areas. Prints are made by applying paper, under pressure, to the inked surface.

Senefelder's partner's brother, P. André, came in 1800 to London, where, in 1803, he published an album in six parts, each containing six prints, entitled *Specimens of Polyautographs*. These were reprinted, with additional prints, in 1806, by G. J. Volleweiler. It is possible that Blake's *Enoch* was among the additional prints in this second issue, for Fuseli was among the contributors, and he may have suggested that Blake should be invited to contribute.[68]

This becomes more likely if we remember that any artist can draw a

67. Ibid., pp. 127–29.

68. Keynes, *Separate Plates*, pp. 43–44. According to Felix Man, 'Lithography in England (1801–1810)', published by Care Zigrasser in *Prints*, New York, 1962, pp. 128–30, Blake's *Enoch*, although 'clearly recognizable as a Volleweiler print', was never published and was not included in any part of *Specimins of Polyautographs*.

design on the lithographic stone, without previous experience of the lithographic process. Provided the correct ink or chalk is used the drawing may be made directly on the cleaned printing surface, which may then be handed to the printer, who will carry out the remainder of the process from desensitising to printing. In this way, Blake might have been commissioned to make a drawing as a contribution to the album, without any preliminary understanding of lithography. This might be the explanation, also, of why he never made another lithograph, although it may simply have been that he found the process unsympathetic.

From what has been written already, one thing will be obvious: Blake was a great experimenter with techniques. As in his poetry and mythology, so in the mechanics of his art he could say,

> I must Create a System or be enslav'd by another Man's.
> I will not Reason & Compare: my business is to Create.[69]

Create he did, building his technique on what was best in tradition and adapting and modifying it for his own purposes. In 1807, the following memorandum was entered in his note-book:

> To Woodcut on Pewter: lay a ground on the Plate & smoke it as for Etching; then trace your outlines, and beginning with the spots of light on each object with an oval pointed needle scrape off the ground as a direction for your graver; then proceed to graving with the ground on the plate, being as careful as possible not to hurt the ground, because it, being black, will shew perfectly what is wanted.[70]

It should be explained in passing that Blake's definition would be better described as wood-engraving rather than woodcutting, the print being conceived in white lines on a black background. A woodcut ordinarily means a print from a block cut with a knife along the grain or plank of the wood, the print usually being black on white. The opposite effect is obtained in a wood-engraving, which is printed from a block (usually boxwood) cut with an engraving tool on the end of the grain.

For fineness of line and finish the method of engraving on pewter gives the best results. Many of the splendid engravings of Miss Joan

69. *Jerusalem*, K.629.
70. K.440. Blake recommended pewter to his friend George Cumberland, who wrote in his memorandum book on 12 April 1813: 'I saw Blake who recommended Pewter to scratch on with the prints.' (B.M. Add. MS. 36520 f. 155.)

Hassall[71] are cut on printer's metal, which gives the same effect as pewter; the sharp brilliance of her work shows the special quality that a metal block can bring to this technique. Blake exploited it to the full, and the method enabled him to bring great strength and originality to his printed work.

The adaptation of wood engraving to a metal surface had been used centuries before Blake's time, but had been neglected or discarded in the intervening years and rediscovered by him. Many of the 'wood cuts' in old-printed Books of Hours of the fifteenth and sixteenth centuries, from the *ateliers* of such printers as Gillet and Germain Hardouin, and Thielman Kerver,[72] were cut on metal. They were white-line engravings, exactly the same as Blake proposed in his memorandum, and made. In other words the design appeared in white on a black background, the passages which were to appear white being cut in the metal surface by a burin or some other form of engraving tool, and the surface itself being inked for printing. Some of the white dots and lines which were a frequent feature of these engravings, were made by punches.

It is interesting to observe that these fifteenth–sixteenth century engravings had been inspired by the examples of woodcuts. In Blake's case the inspiration was reversed, the wood engraving that was being revived at the time suggesting to him that the same effect could as well or better be achieved on metal.

Be that as it may, Blake used the process both for separate plates, and for those in his illuminated books; its application to the latter will be discussed more fully in Chapter 5, but one or two points may be noted in passing.

Most important of all is that in this technique Blake seems to be especially Blake-like. Those special visionary qualities which are associated with his work thrive in it—the white lines and areas seeming to grow, and to be, as it were, illuminated against the dark surface of the block. This is apparent in his designs for the broadsheet, 'Little Tom the Sailor', which he engraved at the instigation of William Hayley, and in the brilliant print, 'The Man Sweeping the Interpreter's Parlour', in which the swirling clouds of dust have that typical 'thumb-print' composition often seen in Blake's visionary

71. See McClean, Ruari, *The Wood Engravings of Joan Hassall*, London, 1960.
72. See Lacombe, Paul, *Livres d'Heures imprimés au XVᵉ et au XVIᵉ Siècle*, Nieuwkoop, 1963.

work (Plates 24 and 25). In this form of engraving Blake found a release from what must have been the tedious monotony of the conventional technique of trade engraving. It is even more complete a departure from that than was his most highly developed line-engraving technique, as used in the *Job* illustrations.

Blake introduced colouring into some of his pewter 'wood engravings'. In some impressions of 'Little Tom', both transparent and opaque water colours, in grey and sepia, were sometimes used to improve their appearance.

This form of engraving also made it possible for Blake to make important psychological variations in his compositions. This may be observed by comparing the line-engraving *The Dance of Albion* with the 'woodcut' on pewter, plate 76 of the illuminated book *Jerusalem* (Plates 19 and 26). The *Jerusalem* plate, realised in white lines on a black background, gives a more sombre and mysterious atmosphere than that engendered by the brighter black on white realisation of the line-engraving. The figure of the dancing Albion, too, is confident, dancing and coming forward joyfully towards the spectator. In the *Jerusalem* plate, Albion is shown from the back, his arms outstretched like those of the crucified Saviour, in a gesture of immolation. Blake knew how to exploit his many techniques to best advantage, and I think this is an illustration of such conscious exploitation.

At the end of his life, Blake branched out into another technique— true wood-engraving. In this, he produced a work—illustrations to Ambrose Philips's *Imitation of Virgil's First Eclogue*—that was destined to have a greater immediate impact than anything else he ever did in the graphic arts, for it was made at a time when a group of talented young artists, including Samuel Palmer, Edward Calvert and George Richmond, were under his influence. The work done by these young men consequent to the Virgil illustrations was a watershed in the pastoral aspect of British Romanticism.

The story of the genesis of the wood-engravings is well known: how they were commissioned from Blake by Dr Robert John Thornton, editor of *The Pastorals of Virgil with a Course of English Reading adapted for Schools* (1821); how Thornton panicked when he saw their unusual appearance, and began to get them recut by a trade engraver; and how, on the insistence of some well-known artists, said to include Sir Thomas Lawrence, he after all printed all but three of them from Blake's original blocks, but only after these had been cut down to

fit the page. How, even then, Thornton remained unsure of them, and only published them with this prefatory note:

> The Illustrations of this English Pastoral are by the famous BLAKE, the illustrator of *Young's* Night Thoughts, and *Blair's* Grave; who designed and engraved them himself. This is mentioned, as they display less of art than genius, and are much admired by some eminent painters.

This is not the place to discuss their aesthetic excellencies, except, in passing, to note that to two of Blake's young followers their effect was overwhelming. Palmer called them 'visions of little dells, and nooks, and corners of Paradise; models of the exquisitest pitch of intense poetry',[73] and to Calvert they seemed to be 'done as if by a child; several of them careless and incorrect, yet there is a spirit in them, humble enough and of force enough to move simple souls to tears'.[74]

These tiny works (one of them measures $2\frac{3}{8}$ by $3\frac{5}{16}$ inches, the remainder about $1\frac{3}{8}$ by 3 inches)[75] contain the concentrated essence of Blake's visual Romanticism. His terrific visions are not to be found in them, but on the other hand they are charged with the most intense essence of that side of him which was concerned with the pastoral element in man's psyche. Their minute, jewel-like conception, too, reminds us of another of Blake's enthusiasms—his admiration of ancient gems, for which we have the authority of Samuel Palmer.[76] Many of the figures in the Virgil illustrations are reminiscent of figures in ancient gems, impressions of which Blake had probably seen in the form of plaster casts in book-like boxes, bought by people on the grand tour when they visited Rome. Similarly, there is something in them reminiscent of Wedgwood's jasper medallions. Blake had almost certainly seen these, for not only were they very popular at the time, but he also worked for Wedgwood, engraving pages for one of his catalogues.

The technique shown in the Virgil wood-engravings is coarse and

73. Palmer, A. H., *The Life and Letters of Samuel Palmer*, London, 1892, p. 15.
74. [Calvert, Samuel], *A Memoir of Edward Calvert Artist by his Third Son*, London, 1893, p. 19.
75. These are the sizes of the smaller blocks in their present state, as cut down to fit on Thornton's pages. Originally they measured from about $1\frac{5}{16}$ to $1\frac{9}{16}$ inches by $3\frac{3}{8}$ inches. The size of the larger block was not reduced. 76. Gilchrist, p. 302.

amateurish, despite Blake's experience in other kinds of engraving. Yet that did not prevent him from instilling considerable power into them. It is possible that Blake did not use special wood-engraving tools; certainly he does not appear to have used everything that was available, and it is even possible that he merely adapted his line-engraving tools for use on the wood. If so, this might account for what appears to be clumsiness in handling—a surprising clumsiness for a professional engraver, even if he was working on unfamiliar material.

The usual wood-engraver's tools are illustrated in Figure 1, and short descriptions of their use are printed there. Normally one would expect the scorper to have been used for making the dots shown on the engraving in Plate 27, but from the shape of the incisions, little wedge-shaped dots, it would appear more likely that they were made by a burin. The whole of the engraving shown in Plate 28 was made by a burin. Passages elsewhere, as in the sky in Plate 29 could have been made by a tint tool, and the beaten-down field of wheat in the same plate could have been made by a spitstick (Figure 1); but in both places they could equally have been made by a burin. Indeed the whole of the engraving of this work could be, and probably is, burin work. If he used a burin solely, Blake would have been following the same precept as his contemporary, Thomas Bewick.

Yet Blake's approach to wood engraving was different from Bewick's. Bewick composed in terms of white lines, paying little attention to chiaroscuro. Blake composed in white lines, too, but he never ignored or forgot the black background of his block. It was as if he were enticing from the wooden surface something that was hidden there, presenting as visions whatever he found. Or, as Laurence Binyon once expressed it, 'Blake's conceptions in these illustrations did not take their final form in the drawings; they were only fully realised on the block itself. Hence they have the character of visions called up as if by moonlight out of the darkened surface of the wood, and seen to have no existence apart from it.'[77]

77. Binyon, Laurence, *Little Engravings Classical and Contemporary Number II. William Blake being all his woodcuts*, London, 1902, p. [ii].
It is interesting, in connexion with the importance of the blackness of the Virgil wood engravings, to note that a coloured set has recently been traced. It is owned by a descendant of John Linnell and was probably printed and coloured either by him or by one of his children, although the choice of colours is said to show an appreciation of Blake's palette. See James, G. Ingli, 'Blake's Woodcuts, Plain and Coloured', *Times Literary Supplement*, 18 May 1973, p. 564, and 'Blake's Woodcuts Illuminated', *Apollo*, March 1974, pp. 194–95.

Nevertheless I do not think that Blake could have been completely uninfluenced by Bewick, whose work was well-known and widely distributed in Blake's lifetime. In this case, as in so many other things, Blake probably took the dry bones of his technique from an established convention, in this case Bewick's, and proceeded to make it his own.

*　　　　*　　　　*

Such, then, was the framework of Blake's trade. The methods described in this chapter, plus the important technique of relief-etching, which will be described in Chapter 5, were the true springboard of all his other excursions into the visual arts. Out of his training and practice as an engraver and etcher he wove a rich tapestry of technique that achieved the promise of Los, the Creative Imagination, 'the sole, uncontroll'd Lord of the Furnaces'.[78]

Few other artists have created with Blake's tenacity of purpose, a tenacity that enabled him to forge his own techniques through which he could express a uniquely visionary message of man and his purpose.

78. *Jerusalem*, K.627.

3

Painting

B LAKE was not alone in his times in being both painter and engraver—it is really his poetry, with which we are not concerned in this essay, which gives him a vast extra dimension as an artistic polymath, not only over his contemporaries, but over most other artists in our tradition. Incidentally, it may be claimed that he is excelled in the art of poetry, if at all, only by Chaucer, Shakespeare, Spenser and Milton. One writer, himself a poet, considers him to be the most profound writer in English after Shakespeare.[1]

Blake was never so thoroughly trained in painting as in engraving, and there is some justice in Gilchrist's remark that, 'In an era of academies, associations, and combined efforts, we have in him a solitary, self-taught and as an artist, *semi*-taught, dreamer....'[2] I am not at all sure, though, that 'dreamer' is the best word in that context, for in matters of technique at least, Blake was always a realist, and even in areas where his instruction had been non-existent or incomplete, he thoroughly mastered the processes he used, and was able to control them perfectly.

We have already seen, in Chapter 2, that Blake attended Pars's drawing academy, but in fact he had, from early childhood, shown artistic tendencies, for as soon as he could hold a pencil he '. . . began to scrawl rough likeness of man or beast, and make timid copies of all the prints he came near. He early began to seek opportunities of educating hand and eye. In default of National Gallery or Museum, for the newly founded *British* Museum contained as yet little or no sculpture, occasional access might freely be had to the royal palaces. Pictures were to be seen also in noblemen's and gentlemen's houses, in the sale-rooms of the elder Langford in Covent Garden, and of the elder Christie: sales exclusively filled as yet with the pictures of the

1. Sitwell, Sacheverell, *Journey to the Ends of Time*, London, 1959, p. 128.
2. Gilchrist, p. 2.

'old and dark' masters, sometimes genuine, oftener spurious, demand
for the same exceeding supply. Of all these chances of gratuitous
instruction the boy is said to have sedulously profited: a clear proof
other schooling was irregular.'[3]

As in his engraving, so in his painting Blake worked in several
techniques: in water-colour, in a process he called fresco, and in
miniature. Oil he rejected, although there is evidence that he once
flirted with it, for there is an early sketch in oil, dated 1776, and
signed by Blake, in the Huntington Library at San Marino, California.
It is a copy of a figure from Michelangelo's 'Last Judgement'. Some
details of his early rejection of oil are given by Frederick Tatham:

> Oil painting was recommended to him, as the only medium through
> which breadth, force, & sufficient rapidity could be obtained; he made
> several attempts, & found himself quite unequal to the management of it;
> his great objections were, that the picture after it was painted, sunk so
> much that it ceased to retain the brilliancy & luxury that he intended, &
> also that no definite line, no positive end to the form could even with
> the greatest of his Ingenuity be obtained, all his lines dwindled & his
> clearness melted, from these circumstances it harrassed him, he grew
> impatient & rebellious, & flung it aside tired with ill success & tormented
> with doubts. He then attacked it with all the Indignation he could collect,
> & finally relinquished it to men, if not of less minds of less ambition.[4]

In short, he found himself incapable of expressing his all-important
bounding line in the medium. His hatred of oil painting became more
intense as he grew older, and by 1809 he was expressing it with con-
siderable vehemence:

> Oil has falsely been supposed to give strength to colours: but a little
> consideration must shew the fallacy of this opinion. Oil will not drink
> or absorb colour enough to stand the test of very little time and of the
> air. It deadens every colour it is mixed with, at its first mixture, and in a
> little time becomes a yellow mask over all that it touches. Let the works
> of modern Artists since Rubens' time witness the villany of some one of
> that time, who first brought oil Painting into general opinion and practice:
> since which we have never had a Picture painted, that could shew itself
> by the side of an earlier production. Whether Rubens or Vandyke, or

3. Ibid., p. 6. 4. *Life of Blake, Blake Records*, p. 515.

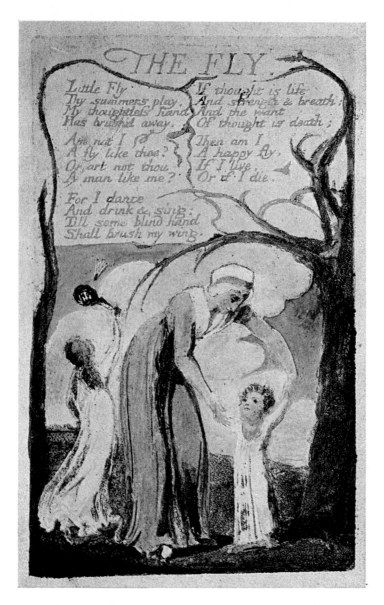

III The Fly, from *Songs of Experience*. Illuminated relief-etching. 4$\frac{11}{16}$ by 2$\frac{13}{16}$ ins. *Private Collection*

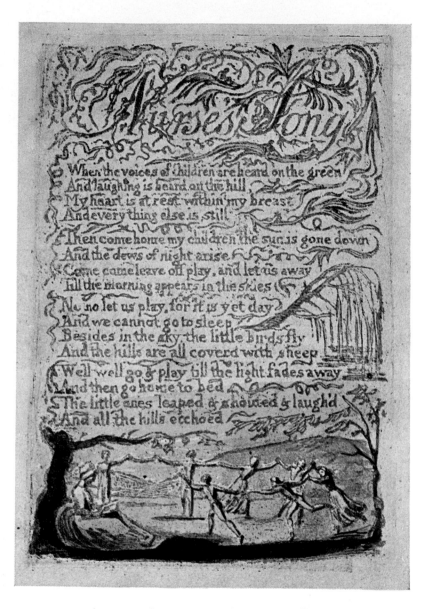

IV Nurse's Song, from *Songs of Innocence*. Illuminated relief-etching. $4\frac{9}{16}$ by $3\frac{1}{16}$ ins. *Private Collection*

both, were guilty of this villainy, is to be enquired in another work on Painting, and who first forged the silly story and known falsehood, about John of Bruges inventing oil colours: in the meantime let it be observed, that before Vandyke's time, and in his time all the genuine Pictures are on Plaster or Whiting grounds and none since.[5]

Instead of using oil, Blake used 'fresco', a technique invented by himself, and we shall return to that shortly. In the meantime we will examine his methods of using water-colour, the medium he used most frequently. It was in this that he painted subject-matter ranging from the Bible to English history, from Shakespeare and Milton to Dante, and from Thomas Gray to Edward Young, some of this work being the most original ever painted in the medium.

Most of Blake's water-colours were preceded by a preliminary drawing, amounting often to no more than a few lines, a shorthand note of what he was aiming at (Plate 30). Yet this preliminary drawing was no sketch; Blake abhorred the idea of sketching: 'No good Artist will or Can sketch', he wrote.[6] On the other hand, Blake's first drawings for his water-colours have a dynamic quality, a firm decisiveness which is usually followed throughout the progress of the work without diminution. In a letter to an unknown correspondent, written about 1849, Samuel Palmer writes of Blake's 'first inventive lines—from which he was always most careful not to depart', and he goes on to remark that, 'the state in which Blakes drawings and those of other inventors are most interesting to myself are either the finished state or that in which the first thought is just breathed upon the paper'.[7]

At times Blake worked up and finished his drawing in either pencil or indian ink, and left it at that, without proceeding to water-colour. But whether the preliminary drawing was left in its original form, or worked up into something more elaborately finished, time and time again, and with a very few exceptions, this decisiveness is evident— the first lines enduring, with little modification, through to the finished work. It is as if Blake had dashed a few lines on to the paper as an *aide memoire*, as if he had already, in his mind, seen in a flash what the finished work was to be. In this he was following his own precept that the best drawings are executed 'with a firm & decided hand at once'.[8]

5. K.565. 6. K.542.
7. Lister, Raymond (ed.), *The Letters of Samuel Palmer*, Oxford, 1974, letter 1849 (12).
8. *Public Address*, K.595.

D

This is by no means an universal experience among creative artists, many, perhaps most of whom develop, modify and refine their conceptions as their work progresses. Indeed, a work that is minutely planned and painted exactly as it is first conceived, often, in the end, lacks immediacy and vitality. That this is not so in Blake's work is due to the strength of his imagination, and a strong intuition of what was in each case the right approach.

But lest we make the mistake of looking on Blake merely as a kind of inspired visionary, let us remind ourselves that his immediacy and intuition were based on a very strong sense of tradition, backed up by considerable erudition in the history of art. We now know that he used many sources for his figures and composition,[9] and we have before us his own dictum: 'The difference between a bad Artist & a Good one Is: the Bad Artist Seems to Copy a Great deal. The Good one Really Does Copy a Great deal.'[10] Indeed he borrowed freely from his collection of prints, and from sculpture and painting that he saw in galleries and exhibitions. He was influenced even by Hindu thought and art.[11]

The same is true of his techniques. As we have seen in Chapter 2, he worked freely and dextrously in a number of traditional engraving and etching techniques, and while, where necessary, he used them in traditional ways, his real originality is to be found in those works in which he mastered them and adapted them to his own purpose, as in the Virgil wood-engravings and the *Job* line-engravings. So it is, as we shall see, with his painting techniques.

But let us return to Blake's water-colours, with first a word about their preparation: in those days it was more usual for water-colour painters to buy colours in powder form than in soluble cakes, although these had been invented by the firm of Reeves as long ago as about 1780, an invention that earned them a premium from the Society of Arts. By 1801 Ackermann was also marketing such cakes, and other firms soon followed. But Blake preferred to continue as he had begun, that is to grind his own colours from the powder. He probably found the soluble cakes too hard, for the invention of moist colours in pans did not occur until about 1832, when they were listed by Winsor and Newton. Before that it was often difficult to remove the colour

9. Blunt, op. cit. 10. K.455–56.
11. Nanavutty, Piloo, 'William Blake and Hindu Creation Myths', *The Divine Vision* (ed. V. de Sola Pinto), London, 1957, pp. 163–82.

from the cakes, and brushes were worked hard, and eventually worn, by the friction necessary for this. Another method of removing colour from a cake was to agitate it in a saucer of water; this was fine for producing tints, but generally unsuitable for rich colouring.

For grinding his colour, Blake used as a base a slab of marble, mixing the powder with diluted carpenter's glue. His palette was of small range: according to Gilchrist, it was restricted to 'indigo, cobalt, gamboge, vermilion, Frankfort black freely, ultramarine rarely, chrome not at all'.[12] His brushes were of camel's hair; he disliked, and never used, sable.[13]

Blake worked in several different variations of water-colour, each one of which will be examined, and first we will consider the one he used for large water-colours such as the series for Dante, Young's *Night Thoughts*, and Gray's poems. In these Blake began with a preliminary drawing of the subject in light pencil or chalk lines, but instead of being left as a separate study, this was used as a foundation for the finished water-colour, and in many water-colours from these series the original light lines may be clearly seen, especially in those rare cases in which Blake changed his mind, as work progressed, about details of the composition. The next stage was to go over the pencil lines, strengthening them with lines drawn with a brush or pen, in indian ink, or, in a few cases, by firmer pencil.

Colouring was then added, generally in a broad *premier coup* wash technique, but in some cases retouchings and highlights were afterwards added in water-colour or pen-and-ink work. In a long series, like the Dante and Gray water-colours, the earlier works are sometimes more highly finished than the later ones. This does not seem to be attributable to Blake's becoming bored as the series progressed, but was probably merely that Blake considered some subjects best treated in one way, some in another. Yet it would not have been strange if he had become bored—there were 537 water-colours in the *Night Thoughts* series, for which he received about 9d. each; the Gray designs numbered 116, and those for Dante, unfinished at Blake's death, 102.

Blake was, in the *Night Thoughts* and Gray designs, faced with the difficult task of fitting them into a scheme in which each surrounded a rectangle, containing part of a poem, in the middle of the page.

12. Gilchrist, p. 60. Frankfort black was probably the 'German flute colour' mentioned in a letter to the publisher, Richard Phillips, in June 1806, K.864.
13. Ibid. and p. 312.

On the whole he overcame the challenge with brilliance, especially in the Gray series, which were painted after the *Night Thoughts*; presumably Blake had, in executing that extensive series, gained great experience which he put to inspired use in the Gray water-colours.

But the finest of Blake's large water-colours, both in technique and artistic accomplisment, are his Dante designs. In these he had perfect control over his medium, unhampered by working in a difficult space. By a perfect use of simple washed colour, he conveys an amazing variety of spatial tensions, as in the infinity of sky, vast area of sea, and colossal height of cliff in 'The Proud under their Enormous Loads' (No. 81),[14] or in the smouldering abyss of 'The Pit of Disease: the Falsifiers' (No. 58) (Plates 31 and 32).

The Dante drawings vary considerably in execution. Some, especially towards the end of the series, are little more than preliminary outlines, no doubt left thus because the artist died while he was working on them.[15] Others are typical of the extremes of Blake's work in this branch of water-colour, some *premier-coup*, like 'The Minotaur' (No. 22, Plate 33), others elaborately finished and retouched, like 'Beatrice addressing Dante from the Car' (No. 88, Plate 34). There are also considerable variations in the degree of outlining; there are examples such as 'The Lawn with the Kings and Angels' (No. 76, Plate 35), in which everything, including every leaf of the trees which form an important part of the design, are (with the exception of certain unfinished areas which are still in pencil) outlined in indian ink and tinted with light washes. Again, some, while remaining, as in the majority of Blake's work, vividly and definitely outlined, are yet executed with less detail and greater boldness, like 'The Simoniac Pope' (No. 35, Plate 36), one of the most splendid works in the series, and indeed in the whole of Blake's *œuvre*. This, too, is executed in washes of great brilliance and intensity—orange, red and blue, enclosed by *cloisonné*-like indian ink outlines.

In these water-colours Blake, at the end of his life, introduced a new dimension into his technique, which may be seen to perfection in 'The Simoniac Pope' and 'Beatrice addressing Dante'. This consisted

14. These numbers indicate the place of the drawings in the Dante chronology. They are reproduced in that order and so numbered in Roe, *Blake's Illustrations to the Divine Comedy*. This is the best book on the series.

15. Several extremely interesting unfinished drawings in the series are in The National Gallery of Victoria, Melbourne. See Hoff, Ursula, *The Melbourne Dante Illustrations of William Blake*, Melbourne, 1961. Others are in the Tate Gallery.

of taking the final stage of added retouchings and highlights to a much more complicated conclusion, sometimes covering the whole surface with them. This required great care if a muddy effect were to be avoided, and it is clear that Blake allowed the original washes to dry thoroughly, and then added the final strokes over them, keeping his brush as dry as possible so as to avoid disturbing the under surface, yet allowing it to remain damp enough to be manageable.

It is possible that, in order to help him gain these ends, he added a minute amount of glair[16] to the water. This would have had the added effect of making the colours as brilliant as possible, and the brilliance of such a work as 'The Simoniac Pope' seems to support this theory. It was, too, a device widely used by mediaeval illuminators and miniaturists, partly for the reason just stated, and partly to keep the colours from mingling as successive layers were added which, as we have just seen, was Blake's problem.

The intensity of colours in mediaeval miniatures and illuminations was obtained also by superimposing one colour on another. Thus, flesh would be begun by laying a ground of *terre vert*, then gradually adding the mouldings of muscle and features in white, carnation, and sometimes adding a final touch of gold. This tradition was adopted by early portrait miniaturists like Hans Holbein and Isaac Oliver, and again it accounts for the clean brightness of their colours, as it may, to some extent, account for the brightness of those of Blake.

Yet despite the possibilities offered by this method in moulding forms, Blake was unable to satisfy himself in this respect: once, on seeing an historical picture by a contemporary, he said, 'Ah! that is what I have been trying to do all my life—to paint *round* and never could.'[17] There is much in his *œuvre* to belie that modest claim, not least among the Dante water-colours. But one can appreciate his meaning, for many of his works give the impression of *basso-relievo* rather than full sculptural quality, and some of this is due to his concentration on the bounding line, rather than on its infilling. And, of course, his dislike of chiaroscuro did not help. The contrast of light and shadow is essential if an artist is to convey a three-dimensional effect; but to Blake it was, 'that infernal machine called Chiar Oscuro, in the hands of Venetian and Flemish Demons, whose enmity to the

16. White of egg beaten to a froth, with 2 or 3 oz. of water added. It is left overnight before being used. Another possibility is that Blake used gum arabic solution, which would have given the same effect. 17. Gilchrist, p. 312.

Painter himself, and to all Artists who study in the Florentine and
Roman Schools, may be removed by an exhibition and exposure of
their vile tricks'.[18]

Like the Elizabethan miniaturist, Nicholas Hilliard, Blake believed
that 'the lyne without shadowe showeth all to a good jugment, but
the shadowe without lyne showeth nothing'.[19] Or, in Blake's own
words, '. . . the dawbed black & yellow shadows that are found in
most fine, ay, & the finest pictures, I altogether reject as ruinous to
Effect, tho' Connoisseurs may think otherwise.'[20] And, more emphat-
ically, 'Moderns wish to draw figures without lines, and with great
and heavy shadows; are not shadows more unmeaning than lines,
and more heavy? O who can doubt this!'[21]

Blake owned a copy of Cennino Cennini's *Tratto della Pittura*, and
we have the authority of John Linnell, who gave the book to Blake,
that he 'soon made it out & was gratified to find that he had been
using the same materials & methods in painting as Cennini describes'.[22]
In one place, Cennini gives instructions for painting a face, and,
although Cennini is describing fresco, it closely resembles the method
described above:

> Let us suppose that you can paint in one day the head only of a young
> male or female saint, such as that of our most holy Lady . . . procure a
> glazed vessel; the vessels should be all glazed and shaped like drinking or
> beer glasses, with a good heavy bottom that they may stand firmly,
> and not spill the colours. Take as much as a bean of dark ochre (for there
> are two kinds of ochre, light and dark); and if you have no dark ochre,
> take light ochre ground very fine; put it into your vase, and take a little
> black the size of a lentil, mix it with the ochre; take a little bianco sangio-
> vanni (lime-white) as much as the third of a bean, and as much light
> cinabrese as will lie on the point of a pen-knife; mix all these colours
> thoroughly together, and make them flowing and liquid with water,
> without tempera. Make a sharp brush of fine soft bristles, which may be
> introduced into the quill of a goose, and with this brush indicate with
> proper expression the face you are going to paint (remembering that the
> face is divided into three parts, namely, the forehead, the nose, and the
> chin, with the mouth), and with your brush nearly dry, put on this

18. *Descriptive Catalogue*, K.582.
19. *A Treatise Concerning the Arte of Limning*, Walpole Society, 1911–12, p. 28.
20. Letter to Thomas Butts, 22 November 1802, K.815.
21. *Descriptive Catalogue*, K.577.
22. Letter to Mrs Anne Gilchrist, 10 December 1862; Ivimy MSS.

colour, little by little, which is called in Florence verdaccio, and in Siena Bazzèo. When you have sketched out the form of the face, if the proportions or any other thing should displease you, with a large brush steeped in water, by rubbing over the intonaco, you can efface and repair what you have done. Then take a little verde-terra, very liquid, in another vase, and with a hog's-bristle brush, without a point, squeezed with the fingers and thumb of the left hand, begin to shade under the chin, and all those parts of the face which should be darkest—under the lips, the corners of the mouth, under the nose, and under the eyebrows, making the shade darker near the nose, a little on the edge of the eye towards the ear; and in the same manner making out with judgment the whole face and hands, which are hereafter to be coloured with flesh-colour. Next take a pointed minever brush, and strengthen all the outlines of the nose, eyes, lips, and ears, with the verdaccio. There are some masters who now, when the face is advanced thus far, take a little bianco sangiovanni tempered with water, and seek out the high lights and reliefs in proper order; then give the rosy colours to the lips and cheeks; then wash over the whole with the flesh-colours very liquid with water, and the colouring is done. It is a good plan to re-touch afterwards the high lights with a little white. Some wash over the whole face with the flesh-colour first; they go picking out with a little verdaccio and flesh-colour, retouching with a little flesh-colour, and the work is finished. This plan is adopted by those only who know but little of the art; but do you follow the method of colouring which I shall point out to you. . . .

First take a small vase; put into it (a tiny morsel is enough) a little bianco sangiovanni, and a little light cinabrese, about as much of one as of the other. Temper them very liquid with clean water; then with a soft bristle-brush, squeezed between the finger and thumb as before, go over the face when you have finished putting it in with verde-terra; and with this red colour (rossetta) touch in the lips and the roses of the cheeks. My master was accustomed to put the colour in the cheeks nearer the ear than the nose, because it assisted in giving relief to the face, and then he softened the rosiness well into the surrounding colours. Then have three small vases, and make three shades of flesh-colour, so that the darkest may be darker by one-half than the rossetta, and the other two each lighter than the other in regular gradations. Now take the little vase containing the lightest tint, and with a very soft bristle-brush without a point take some of this flesh-colour, squeezing the brush with the fingers, and pick out the reliefs of the face; then take the vase containing the middle tint of the flesh-colour, and paint the middle tint of the face, hands, and body, when you paint a naked figure. Afterwards take the third vase of flesh-colour, and go to the edges of the shadows, but always

taking care at the contours that the verde-terra should not lose its value, and in this manner keep on softening one flesh-tint into another, until it is all covered as well as the nature of the work will permit. But mind that if you would have your work appear very brilliant, be careful to keep each tint of colour in its place, except that with skill you soften one delicately into the other. But seeing others work and practising with your hand, will make you perceive better than seeing it merely written. When you have painted in these carnations, make from them a tint much lighter—indeed almost white, and use this above the eyebrows, on the relief of the nose, the tip of the chin, and the upper eyelids; then take a sharp-pointed pencil of minever, and with pure white put in the whites of the eyes, and above the tip of the nose and a little on the fulness of the mouth, and so touch tenderly such lights. Then put a little black into another vase, and with a brush mark out the outlines of the eyes above the lights of the eyes, and make the nostrils of the nose, and the holes within the ear. Then put some dark sinopia into another vase, paint the under outline of the eyes, the contour of the nose, the brows and the mouth, and shade a little under the upper lip, which must be a little darker than the under. Before you finish these outlines thus, take the said brush and with verdaccio retouch the hair; then with the said brush, put on the lights of the hair with white, and with a watery wash of light ochre, and a soft bristle-brush, cover over the hair as you did the carnations. Mark out the extremities of the shadows with dark ochre, then with a small and very pointed pencil of minever put on the lights of the hair with bianco sangiovanni and light ochre. Retouch the outlines and extremities of the hair with sinopia as you did on the face, all over. And this is sufficient for you for a youthful face.[23]

If we take together the facts that Blake painted the Dante series for Linnell, who gave him this book, and that the book describes a method similar to that used by Blake in his most highly-finished works in the series, I feel sure that we may attribute Blake's source for this refinement of his technique to Cennini's *Trattato*. As I have already remarked Cennini is dealing with fresco in the foregoing passage, but it would certainly not have been beyond the ingenuity of a resourceful artist like Blake to adapt it to water-colour.

While we are on the subject of superimposing paint, we will observe that for long it was thought that Blake varnished some of his water-colours, examples being 'The Penance of Jane Shore in St. Paul's

23. Herringham, Christiana J. (translator), *The Book of the Art of Cennino Cennini*, London, 1899, pp. 58–62.

Church' (on paper; Plate 37) and 'Cain Fleeing' (on panel). But recently the former picture, which is in the Tate Gallery, was cleaned and the varnish removed; it is thought that it might have been applied in the middle of the nineteenth century. There was, however, a thin layer of size—a necessary preliminary to varnishing—under the varnish, and it is thought that Blake might have applied this. The brightness of the water-colour was much improved by the removal of the varnish.[24]

The supposition that Blake probably did not varnish the 'Jane Shore' water-colour does not, of course, prove that he varnished none. Nevertheless, it does raise doubts about the others. Blake, as we have seen, was fond of experimenting with techniques, and it would not be uncharacteristic if he had experimented with varnish. The practice of varnishing water-colours, although never a common practice, arose in the eighteenth century, when they were often exhibited on the same wall as oil paintings, and were not always covered with glass. Among water-colourists who varnished their work was John Varley, who became a friend of Blake in his latter years. Blake might have seen examples so treated by Varley, and perhaps liking the immediate effect, used it himself. On the other hand, it does not, so far as we know, occur on water-colours painted after he had met Varley; so he might have applied varnish to earlier works by way of experiment and, not after all liking the effect, carried it no further. Or he might merely have adopted the practice from what was a general custom at the time.

The method of varnishing water-colours was described in an article by Hesketh Hubbard:

The drawing was first sized with isinglass dissolved in warm water, which was strained through a cloth and allowed to stand till it cooled to the consistency of hartshorn jelly. For use the size was either diluted with hot water or melted over steam until it just acquired fluidity. If the water-colour pigment had been applied with any appreciable degree of impasto the more heavily impasted parts were first sized with a medium-sized soft brush, care being taken not to disturb the pigment. When this preliminary *local* sizing had dried, two or three additional *general* washes of size were floated over the whole of the drawing with a large flat varnish brush. When these washes in turn had dried hard the drawing was slightly heated (to prevent the varnish chilling and sinking into the

24. *Blake Newsletter*, VI, p. 5.

paper) and varnished sparingly with mastic to which a little copal was added if a very highly varnished drawing were desired. A water-colour so protected could be sponged when its surface became dirty. The varnish also brought out the beauty of deep shadows.[25]

I have already mentioned the discovery of a layer of size under the varnish recently removed from 'The Penance of Jane Shore', and to return for a moment to that work, it may be remarked as a possibility that this might have been applied by Blake. If indeed he did apply the size, it would seem that he intended that the work should be varnished, and if the varnish, as is thought, was a mid-nineteenth-century addition, it might have been a second application, after an original coat had been removed, perhaps because the colours were beginning to appear dull. We cannot be sure of this, but at the same time, I submit, neither can we be sure that the drawing was never varnished by Blake, or that he never varnished.[26]

In 1800, at the suggestion of William Hayley the poet, the Blakes settled for a time at Felpham in Sussex, where they were to enjoy the patronage of 'The Hermit' as Hayley liked to call himself. They remained there until 1803, when they returned to London. It had been a disappointing, humiliating and disastrous experience, culminating in a charge of sedition being brought against Blake by a soldier whom he had ordered out of his garden. He was acquitted triumphantly, but it must, just the same, have been a very worrying time.

Hayley, with the best of intentions but little perspicuity, set Blake a whole series of uncongenial tasks while he was at Felpham. The fact is that he had no understanding of Blake's unusual mind and temperament, and Blake confided in his note-book:

> When H[ayle]y finds out what you cannot do,
> That is the very thing he'll set you to.
> If you break not your Neck, 'tis not his fault,
> But pecks of poison are not pecks of salt . . .[27]

25. *Forgotten Methods*, Old Water-Colour Society's Club, XVII, 1940. It should be mentioned that Hesketh Hubbard's remarks about 'varnish chilling and sinking into the paper' are misleading. Hot or cold varnish will be absorbed by absorbent paper.

26. The Tate Gallery owns a varnished colour print (see Chapter 4), 'Christ appearing to the Apostles after the Resurrection', Butlin, *Tate Catalogue*, p. 41. Blake also used varnish on some of his temperas. See p. 53.

27. K.544.

Among the less uncongenial tasks that he set Blake was to paint portrait miniatures. In the early, and happier days of his stay at Felpham, Blake wrote to his friend and patron, Thomas Butts:

Mr Hayley acts like a Prince. I am at complete Ease, but I wish to do my duty, especially to you, who were the precursor of my present Fortune. I never will send you a picture unworthy of my present proficiency. I soon shall send you several; my present engagements are in Miniature Painting. Miniature is become a Goddess in my Eyes, & my Friends in Sussex say that I Excel in the pursuit. I have a great many orders, & they Multiply.[28]

In many ways, Blake had a miniaturist's outlook, for he worked at his best on a small scale, and some of his most tremendous compositions are contained on the page of a book. As he himself wrote:

> Nature & Art in this together Suit:
> What is Most Grand is always most Minute.[29]

This does not mean the same thing as to say that the grandest works are always small—such works as the Sistine Chapel frescos and the tomb of Pope Julius II would belie such a claim. What it does mean is that the grandest works are minutely articulated, attention being given to every detail, however small and unimportant it may seem. The art of miniature, with its fine and gem-like technique, well lends itself to this point of view. It is usually, but not always, conceived on a small scale (the word 'miniature' is derived from the Latin *minium*—a red pigment used by mediaeval miniaturists, and not from *minutus*, meaning small), and this enables the miniaturist to develop every nuance of the 'minute particulars'[30] of his subject.

It is therefore not surprising that Blake should at first have warmed to the idea of working in the medium, even if, in the event, he was to find it tedious in the extreme to paint portraits of people, in some of whom he had not the slightest interest. Even where he had a personal regard for the sitter, he found difficulties, for he had rarely, before this, worked from nature or the living model.[31] To Butts, he wrote:

28. 10 May 1801, K.808. 29. K.547. 30. *Jerusalem*, K.657.
31. It may be noted, in this context, that Blake painted his only two 'naturalistic' landscapes while he was at Felpham. They are 'Landscape near Felpham', now in the Tate Gallery, and a view of Chichester Cathedral. See Butlin, *Tate Catalogue*, p. 76; Blunt, op. cit., p. 68.

Next time I have the happiness to see you, I am determined to paint another Portrait of you from Life in my best manner, for Memory will not do in such minute operations; for I have now discover'd that without Nature before the painter's Eye, he can never produce any thing in the walks of Natural Painting. Historical Designing is one thing & Portrait Painting another, & they are as Distinct as any two Arts can be. Happy would that Man be who could unite them![32]

To the same correspondent, just over a year later, he wrote of the same difficulties:

But You will justly enquire why I have not written all this time to you? I answer I have been very Unhappy, & could not think of troubling you about it, or any of my real Friends. (I have written many letters to you which I burn'd & did not send) & why I have not before now finish'd the Miniature I promiss'd to Mrs. Butts? I answer I have not, till now, in any degree pleased myself, & now I must intreat you to Excuse faults, for Portrait Painting is the direct contrary to Designing & Historical Painting in every respect. If you have not Nature before you for Every Touch, you cannot Paint Portrait; & if you have Nature before you at all, you cannot Paint History; it was Michael Angelo's opinion & is Mine. Pray Give My Wife's love with mine to Mrs Butts; assure her that it cannot be long before I have the pleasure of Painting from you in Person, & then that She may Expect a likeness, but now I have done All I could, & know she will forgive any failure in consideration of the Endeavour.[33]

Finally, in exasperation, he exclaims: '[Hayley] thinks to turn me into a Portrait Painter as he did Poor Romney, but this neither he nor all the devils in hell will never do.'[34]

Yet, despite his dislike, Blake's miniatures are competent works, although they have a hardness that prevents them from being comparable with the work of such masters of the art as Cosway, Engelheart or Smart. It is evident that he did not put the best of himself into them, and instead of being works of inspiration, they remain pedestrian, although one of the few remaining, that of the Rev. Johnny Johnson ('Johnny of Norfolk') has distinctly Blakean overtones (Plate 38).[35]

Apparently Blake was taught miniature painting by Hayley himself who, in a letter to Daniel Parker Coke, written on 13 May 1801,

32. 11 September 1801, K.810. 33. 22 November 1802, K.815.
34. Letter to James Blake, 30 January 1803, K.819.
35. See Lister, Raymond, *British Romantic Art*, London, 1973, pp. 52–53.

said, 'I have recently formed a new artist for this purpose by teaching a worthy creature (by profession an Engraver) who lives in a little cottage very near me to paint in miniature.'

There is nothing original in the actual miniature technique used by Blake; it is of the usual stippled brushwork on ivory. The real importance to his technique of Blake's portrait miniatures lies in the effect they apparently had on his subsequent water-colours. For many of these, painted on his return to London from Felpham, are highly finished in stippled brush strokes, in the manner of miniature painting. They are also frequently outlined in colour. The whole produces a 'tightening' of effect, especially suitable for the small size in which many of his later water-colours are painted. Moreover, on some of them he used gold (a traditional material in miniature painting, as has been already briefly mentioned) in order to heighten the effect of the colour. It is so used on several of his illustrations to Milton's *Paradise Regained*.[36]

Stippling may also, perhaps, have been suggested by Blake's use of stipple-engraving; he did indeed make several stipple drawings before he ever practised miniature painting, as in sepia water-colours of 'The Complaint of Job' (Plate 39) and 'The Death of Ezekiel's Wife' (*c.* 1796). But there is a subtle difference between these and the later small water-colours. For one thing they are much larger (13 by $19\frac{1}{4}$, and $13\frac{3}{4}$ by $19\frac{1}{8}$ inches);[37] for another, the detailing is much closer to engraving than the later water-colours. Indeed they were preliminary designs from which engravings were later made—although more elaborate than usual, typical drawings for engravings usually being simpler wash drawings. The stippling of the later work is much closer to stippling in miniatures, especially when its jewel-like colouring and effect are taken into account.

The workmanship is most refined and painstaking. In 'Raphael conversing with Adam', for example (Plate I), the way in which stippling is used to define the muscular structure of Adam and Eve, showing manly strength in one case, and feminine grace in the other, is perfect. The little strokes are laid on in the direction of the articulation of the muscles, giving the figures vitality despite a certain formality— Eve for instance seems to be dancing lightly on the balls of her feet.

36. Keynes, *Blake Studies*, p. 174.
37. Preston, Kerrison, *The Blake Collection of W. Graham Robertson*, London, 1952, Nos. 48 and 52.

The figure of Raphael, as befits such an ethereal being, is less detailed; it relies much more for its effect on its outline. The foliage and flowers are outlined and filled in with colour, like *cloisonné* enamel, a device which adds to the overall jewel-like effect, recalling Blake's remarks that in a large fresco, his colours 'would be as pure and as permanent as precious stones'.[38]

In 1672, the French artist Claude Boutet, defined miniature painting in this way: 'It is not my Design to make any Enconium on Painting. Many ingenious Men have done that Work to my Hands; but tho' Miniature has been included in what they have said, I shall nevertheless specify the Charateristiks of this Kind of Painting in particular.

1. It is in its Nature more delicate than any of the other sorts.
2. It requires to be beheld near at Hand.
3. It cannot well be executed but in small.
4. It is perform'd on Vellum or Ivory.
5. The Colours are moisten'd with Gum-water only.'[39]

Blake's highly-finished water-colours fulfil each one of these requirements except the fourth—and possibly the fifth would have to be somewhat modified—but even here we may recall that many miniatures have been painted on paper and other materials. They may therefore be claimed as miniatures, not only in technique, but by definition, especially if we recall that the art is not confined to portrait painting, but, especially in illuminated manuscripts, embraces other subjects.

The beauty of effect that this new technique was capable of obtaining is evident in a number of series of water-colours—Bible illustrations, illustrations to *Paradise Lost*, *Paradise Regained*, *Comus* and other minor poems of Milton, illustrations to the Book of Job (three sets, one of which was used as designs for the engravings) and illustrations to the *Pilgrim's Progress* (Plates 40, 41, 42 and 66). Not every one of these drawings is taken to the same point of elaboration, but the most highly finished are as finely wrought as miniatures in illuminated MSS. In others, Blake used his looser method as a basis, but finished in his miniature stippling. Such are 'The Death of St Joseph' and 'The Death of the Virgin' (Plate 43).[40] In these a firm pencil drawing is coloured with washes of brilliant, clear colour, but while the figures

38. *Descriptive Catalogue*, K.566.
39. Quoted from the English edition of 1733 of Boutet's book, *The School of Miniature*, pp. 5–6. Cf. Lister, Raymond, *The Miniature Defined*, Cambridge, 1963, *passim*.
40. Preston, op. cit., Nos. 61 and 16.

are left in outline with little detail, the rayed background is finished with elaborate and colourful stippling. Other refinements are present in 'A Prophet in the Wilderness',[41] in which, on a drawing of pen and indian ink, Blake has worked in body colour—water-colour, that is to say, mixed with white to render it thick and opaque. The effect is rich, but the work lacks the brightness of the more usual stippling, which allows the undercoat of the support (e.g. ivory, card or paper) to shine through the stipple, giving a brilliant effect.

It must, however, be emphasised that none of these fine effects in Blake's work amounted to niggling, a thing he detested:

Nor can an Original Invention Exist without Execution, Organized & minutely delineated & Articulated, Either by God or Man. I do not mean smooth'd up & Niggled & Poco-Pen'd, and all the beauties pick'd out & blurr'd & blotted, but Drawn with a firm & decided hand at once, like Fuseli & Michael Angelo, Shakespeare & Milton.[42]

* * *

Gilchrist relates how, during an interview with Sir Joshua Reynolds, the President of the Academy remarked to Blake, 'Well, Mr Blake, I hear you despise our art of oil painting.' 'No Sir Joshua,' said, Blake, 'I don't despise it; but I like fresco better.'[43]

We have already seen that Blake rejected oil painting, and in its place used a method he called fresco, but which, strictly speaking, was tempera, in which it is probable that he saw greater possibilities of attaining his ideal than in oils: 'Painting is drawing on Canvas, & Engraving is drawing on Copper, & Nothing Else.'[44] Blake described his 'fresco' method in an advertisement, *Exhibition of Paintings in Fresco, Poetical and Historical Inventions, by Wm. Blake* (1809). It will be noted that even here he kept the art of miniature well to the front of his mind:

THE INVENTION OF A PORTABLE FRESCO

A Wall on Canvas or Wood, or any other portable thing, of dimensions ever so large, or ever so small, which may be removed with the same convenience as so many easel Pictures; is worthy the consideration of the Rich and those who have the direction of public Works. If the Frescos

41. Bindman, op. cit., p. 42. 42. *Public Address*, K.595.
43. Gilchrist, pp. 82–83. 44. *Public Address*, K.594.

of APELLES, of PROTOGENES, of RAPHAEL, or MICHAEL ANGELO could have been removed, we might, perhaps, have them now in England. I could divide Westminster Hall, or the walls of any other great Building, into compartments and ornament them with Frescos, which would be removable at pleasure.

Oil will not drink or absorb Colour enough to stand the test of very little Time and of the Air; it grows yellow, and at length brown. It was never generally used till after VANDYKE'S time. All the little old Pictures, called cabinet Pictures, are in Fresco, and not in Oil.

Fresco Painting is properly Miniature, or Enamel Painting; every thing in Fresco is as high finished as Miniature or Enamel, although in Works larger than Life. The Art has been lost: I have recovered it. How this was done, will be told, together with the whole Process, in a Work on Art, now in the Press. The ignorant Insults of Individuals will not hinder me from doing my duty to my Art. Fresco Painting, as it is now practised, is like most other things, the contrary of what it pretends to be.

The execution of my Designs, being all in Water-colours, (that is in Fresco) are regularly refused to be exhibited by the *Royal Academy*, and the *British Institution* has, this year, followed its example, and has effectually excluded me by this Resolution; I therefore invite those Noblemen and Gentlemen, who are its Subscribers, to inspect what they have excluded: and those who have been told that my Works are but an unscientific and irregular Eccentricity, a Madman's Scrawls, I demand of them to do me the justice to examine before they decide.[45]

Although Blake published this announcement in 1809, he had been using tempera certainly since 1790, and perhaps earlier. He was still using it as late as about 1825.

Blake's claim to have rediscovered fresco was, of course, wrong. In fresco the painting is carried out in colours ground in water only, on a wet and freshly-prepared lime-plaster wall. When the plaster has dried, the colours have penetrated it and become part of the hard surface, and cannot be removed unless the plaster is destroyed also. Blake's method was also carried out in water-colours, but that was its only relationship with true fresco. The process, and some of its beauties and shortcomings, were described by Frederick Tatham:

Desiring that his colours should be as pure & as permanent as precious stones, he could not with Oil obtain his End. . . . Blake seemed intended

45. K.560-61.

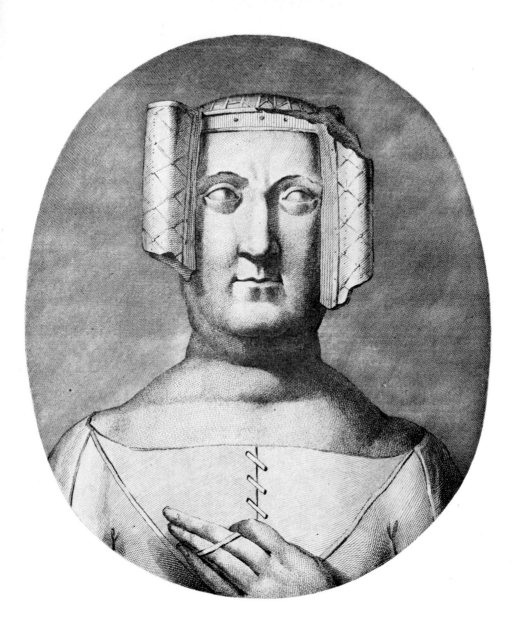

1. Portrait of Queen Philippa from Richard Gough's *Sepulchral Monuments of Great Britain*, Part I, 1786. Line engraving. $12\frac{15}{16}$ by $10\frac{1}{2}$ ins. *Private Collection*

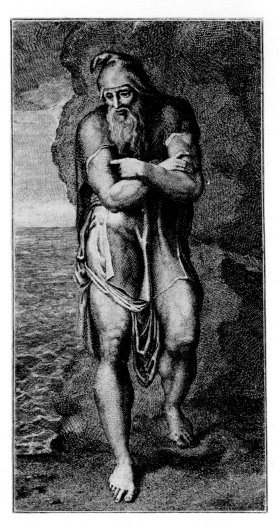

Earth

2. Joseph of Arimathea among the Rocks of Albion. First State, 1773. Line engraving. 10¾ bt 7⅝ ins. *Sir Geoffrey Keynes*

3. Detail from a line engraving of a portrait of John Caspar Lavater after an unknown artist. Showing dot and lozenge technique. 1800. *Private Collection*

4. Plate 3 from *For Children: The Gates of Paradise*. 2⅝ by 2⁷⁄₁₆ ins. *Library of Congress, Washington, D.C.*

5. Plate 14 from *Illustrations of the Book of Job*, 1825. Line engraving with stipple and etching. 7⅝ by 5⅞ ins. *Private Collection*

6. Frontispiece after Fuseli to John Caspar Lavater's *Aphorisms on Man*, 1788. Line engraving. $4\frac{3}{4}$ by $2\frac{15}{16}$ ins. *Private Collection*

7. Portrait of Michelangelo after Fuseli in Fuseli's *Lectures on Painting*, 1801. Line engraving and etching. $4\frac{11}{16}$ by $2\frac{7}{8}$ ins. *Private Collection*

8. Etched background and outlines of a plate by John Romney,
before the engraving of the figures. $4\frac{9}{16}$ by $3\frac{11}{16}$ ins. *Private Collection*

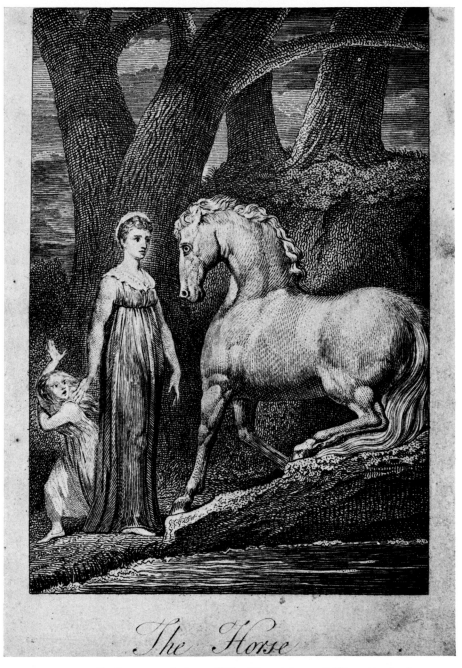

The Horse

9. Proof before completion of 'The Horse' from William Hayley's
Ballads, 1805. Line engraving and etching. $4\frac{3}{16}$ by $2\frac{3}{16}$ ins. *Private
Collection*

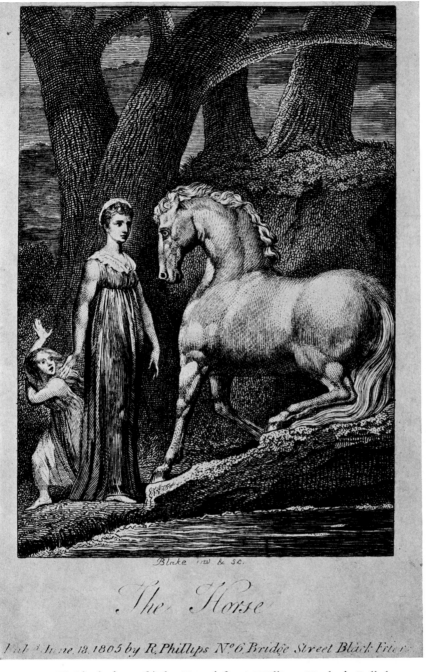

Blake inv & sc.

The Horse

Pub.^d June 18. 1805 by R. Phillips N.^o 6 Bridge Street Black Fri...

10. Finished plate of 'The Horse' from William Hayley's *Ballads*, 1805. Line engraving and etching. $4\frac{3}{16}$ by $2\frac{3}{16}$ ins. *Private Collection*

12. Detail from an illustration after Thomas Stothard for John Hoole's translation of Ariosto's *Orlando Furioso*, 1798. Showing engraved detail on the figure. *Private Collection*

11. Detail from an illustration after Thomas Stothard for John Hoole's translation of Ariosto's *Orlando Furioso*, 1798. Showing etched detail. *Private Collection*

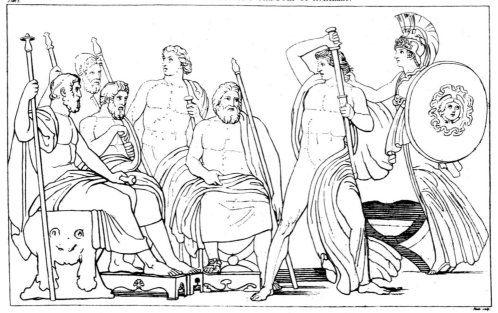

13. Illustration after John Flaxman for *The Iliad of Homer*, 'Minerva repressing the Fury of Achilles', 1805. Line engraving and etching. 6⅝ by 10¾ ins. *Private Collection*

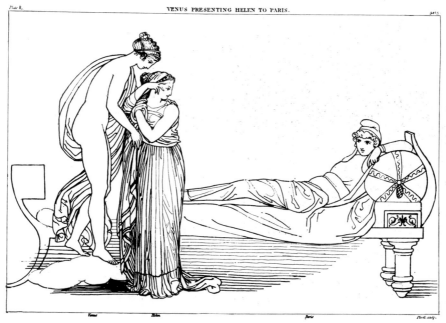

14. Illustration by Piroli after John Flaxman for *The Iliad of Homer*, 'Venus presenting Helen to Paris', 1805. Line engraving. 6⅝ by 9⅝ ins. *Private Collection*

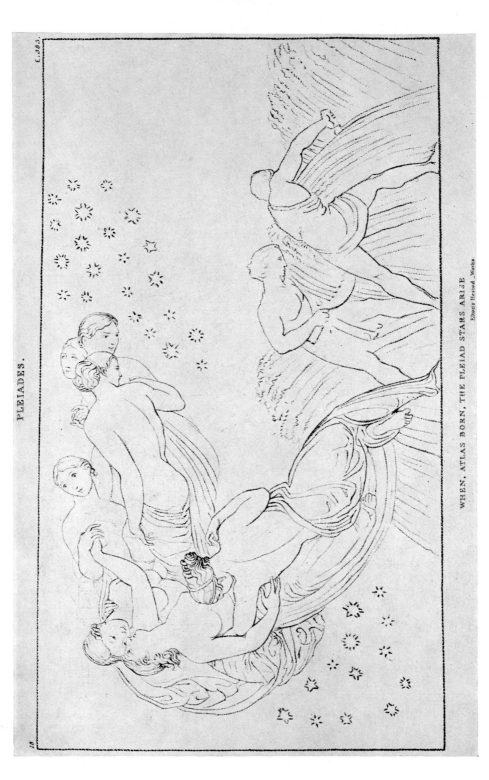

PLEIADES.

WHEN, ATLAS BORN, THE PLEIAD STARS ARISE

Ellatii Hesiod _Works.

15. Illustration after John Flaxman for *The Theogony Works and Days and the Days of Hesiod*, 'Pleiades', 1817. Chalk-line engraving. $5\frac{1}{16}$ by $9\frac{3}{16}$ ins. *Private Collection*

25

We thwart the DEITY; and 'tis decreed,
Who thwart his will shall contradict their own:
Hence our unnatural quarrel with ourselves;
Our thoughts at enmity; our bosom-broil:
We push time from us, and we wish him back;
Lavish of lustrums, and yet fond of life;
Life we think long, and short; death seek, and shun;
Body and soul, like peevish man and wife,
United jar, and yet are loth to part.
 Oh the dark days of vanity! while here,
How tasteless! and how terrible when gone!
Gone! they ne'er go; when past, they haunt us still;
The spirit walks of every day deceased;
And smiles an angel, or a fury frowns:
Nor death, nor life delight us—if time past,
And time possess'd, both pain us, what can please?
That which the DEITY to please ordain'd—
Time used: the man who consecrates his hours
By vigorous effort and an honest aim,
At once he draws the sting of life and death;
He walks with nature—and her paths are peace.
 Our error's cause and cure are seen: see next
Time's nature, origin, importance, speed;
And thy great gain from urging his career.
All-sensual man, because untouch'd, unseen,
He looks on time as nothing: nothing else
Is truly man's; 'tis fortune's—Time's a God:
Hast thou ne'er heard of time's omnipotence?
For, or against, what wonders can he do—
And will! to stand blank neuter he disdains.

16. Illustration for Edward Young's *Night Thoughts*, 1797. Line
engraving. 16 by 12 ins. *Private Collection*

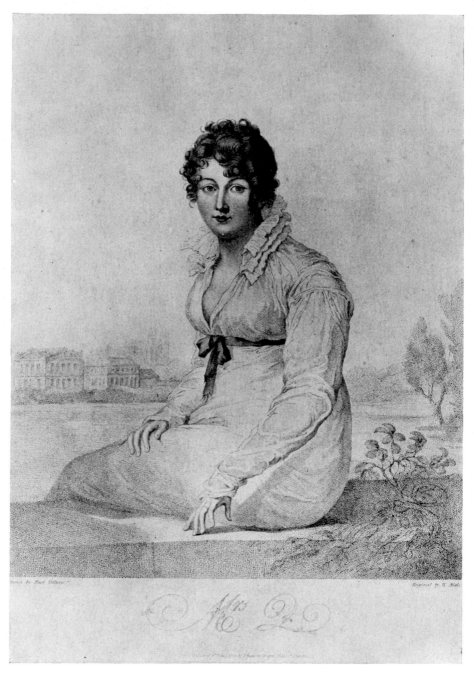

17. Mrs Q. (Mrs Harriet Quentin) after Huet Villiers, 1820.
Stipple engraving in colours. $11\frac{9}{16}$ by 9 ins. *Private Collection*

18. The Fall of Rosamund, after Thomas Stothard, 1783. Engraving in line and stipple. $11\frac{15}{16}$ ins. diameter. *Private Collection*

GLAD·DAY

RUSSELL 3

19. The Dance of Albion, 1780–*c.* 1790. Line engraving. 10¾ by 7¼ ins. *British Museum*

Our Father which art in Heaven.　hallowed be thy Name

1

Thus did Job continually

There was a Man in the Land of Uz whose Name was Job. & that Man was perfect & upright

The Letter Killeth
The Spirit giveth Life

It is Spiritually Discerned

& one that feared God & eschewed Evil. & there was born unto him Seven Sons & Three Daughters

WBlake inv & sculp

London. Published as the Act directs. March 8: 1825, by Will™ Blake N³ Fountain Court Strand.

20. Plate 1 from *Illustrations of the Book of Job*, 1825. Line engraving with stipple and etching. $7\frac{1}{8}$ by $5\frac{13}{16}$ ins. *Private Collection*

21. The Six-footed Serpent attacking Agnolo Brunelleschi, from *Illustrations of Dante*, 1827. Line engraving. $9\frac{9}{16}$ by $13\frac{5}{16}$ ins. *Private Collection*

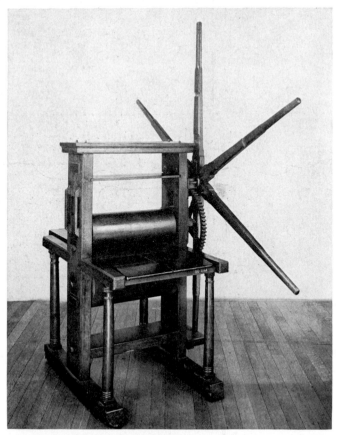

22. Wooden rolling press, probably similar to that used by Blake. *Crown Copyright, Science Museum, London*

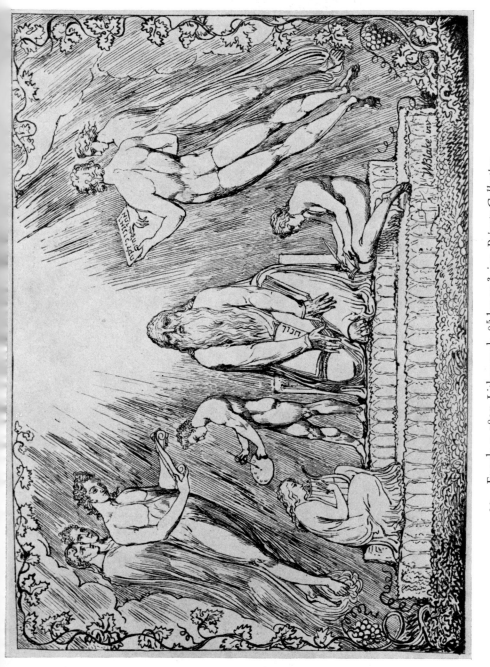

23. Enoch, c. 1807. Lithograph. 8⅝ by 12 3/16 ins. *Private Collection*

24. Little Tom the Sailor, 1800. Woodcut on pewter, lettering relief-etched. *British Museum*

25. The Man Sweeping the Interpreter's Floor, 1794–1822. Woodcut on pewter. $3\frac{1}{8}$ by $6\frac{5}{16}$ ins. *Sir Geoffrey Keynes*

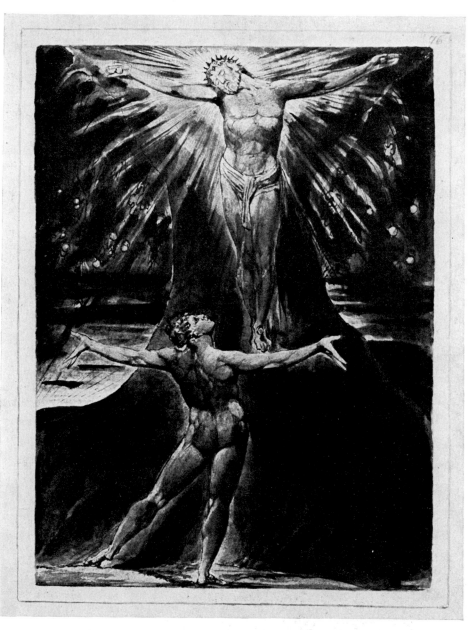

26. Plate 76 of *Jerusalem*, 1804. Illuminated woodcut on pewter.
$8\frac{7}{10}$ by $6\frac{3}{10}$ ins. *Mr. and Mrs. Paul Mellon*

27. Illustration to Thornton's *Virgil*, 1821. 'This night thy care
with me forget and fold/thy flock with mine, to ward th' injurious
cold.' Wood engraving. $1\frac{3}{8}$ by $2\frac{15}{16}$ ins. *Private Collection*

28. Illustration to Thornton's *Virgil*, 1821. 'and now behold the
sun's departing ray,/o'er yonder hill, the sign of ebbing day:/with
songs the jovial hinds return from plow.' Wood engraving. $1\frac{3}{8}$ by
3 ins. *Private Collection*

29. Illustration to Thornton's *Virgil*, 1821. 'Sure thou in hapless
hour of time wast born,/when blightning mildews spoil the rising
corn . . .' $1\frac{5}{16}$ by $2\frac{7}{8}$ ins. *Private Collection*

30. Falconberg taking leave of King John and his mother Queen
Eleanor, *c.* 1819. From the Blake-Varley Sketchbook. Pencil
drawing. 6⅛ by 7⅞ ins. *Private Collection*

31. The Proud under their Enormous Loads, from the Dante
series, *c.* 1824. Water-colour. 20¾ by 14¾ ins. *City of Birmingham Art
Gallery*

32. The Pit of Disease: The Falsifiers, from the Dante series, *c.* 1824. Pen and water-colour. 14⅝ by 20¾ ins. *Tate Gallery*

33. The Minotaur, from the Dante series, *c.* 1824. Water-colour. 14⅝ by 21⅝ ins. *Fogg Museum of Art*

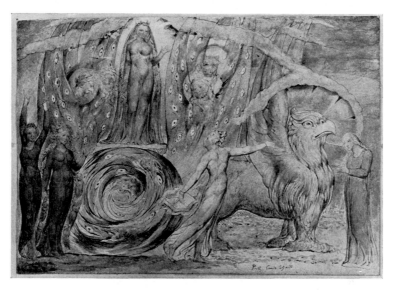

34. Beatrice addressing Dante from the Car, from the Dante series, *c.* 1824. Pen and water-colour. 14⅝ by 20¾ ins. *Tate Gallery*

35. The Lawn with Kings and Angels, from the Dante series, *c.* 1824. Pen and water-colour. 14½ by 20⅝ ins. *National Gallery of Victoria*

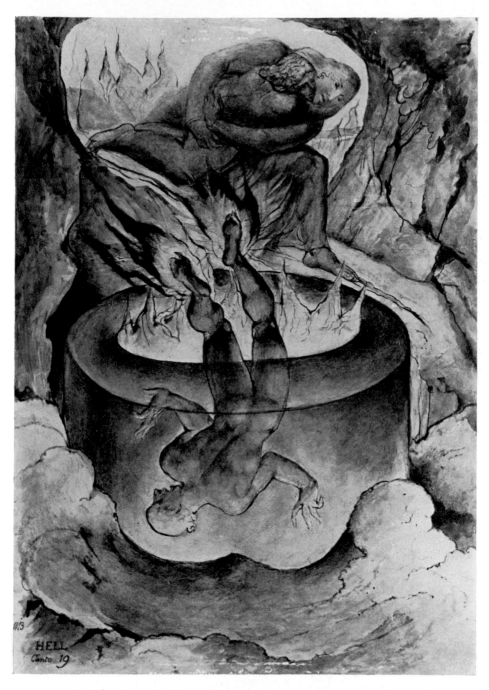

36. The Simoniac Pope, from the Dante series, *c.* 1824. Pen and water-colour. 20¾ by 14½ ins. *Tate Gallery*

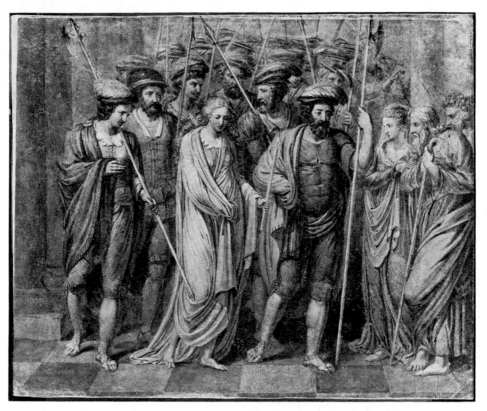

37. The Penance of Jane Shore in St Paul's Church, *c.* 1779.
Ink and water-colour. $9\frac{5}{8}$ by $11\frac{5}{8}$ ins. *Tate Gallery*

38. The Rev. Johnny Johnson. Miniature. 3¾ by 3 ins. *Miss Barham Johnson*

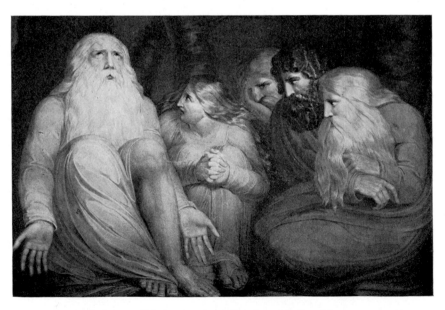

39. Complaint of Job. Brush and ink wash (sepia) over pencil. 13 by 19¼ ins. *Inv. no. (19) 69.30.215. Achenbach Foundation for Graphic Arts. The Fine Arts Museums of San Francisco*

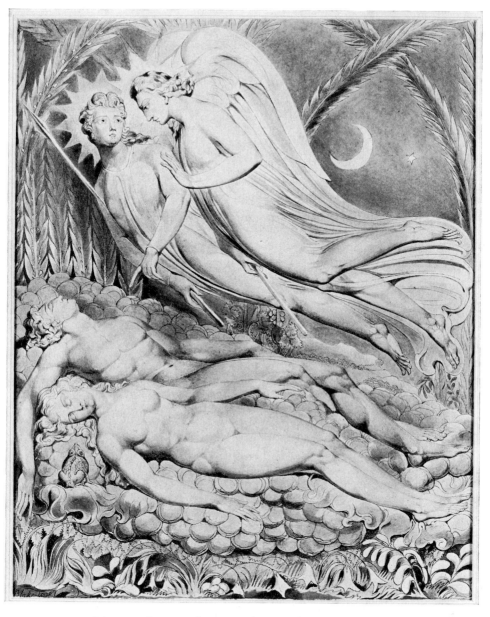

40. Adam and Eve Sleeping, from *The Paradise Lost* series.
Water-colour. 19⅜ by 15¼ ins. *Boston Museum of Fine Arts, Boston,
Mass.*

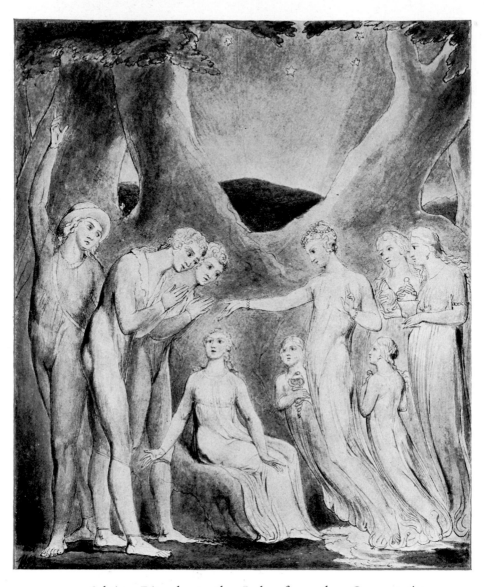

41. Sabrina Disenchants the Lady, from the *Comus* series.
Water-colour. 8½ by 7⅛ ins. *Henry E. Huntington Art Gallery*

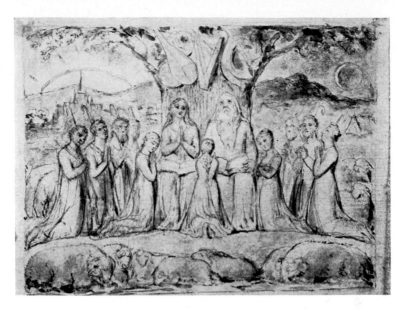

42. Job and His Family. Pencil. *Fitzwilliam Museum*

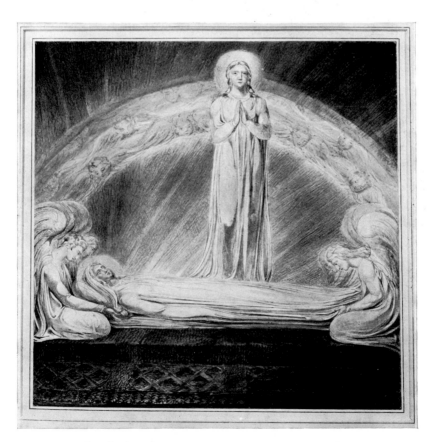

43. Death of The Virgin, 1803. Water-colour. 14⅞ by 14⅝ ins.
Tate Gallery

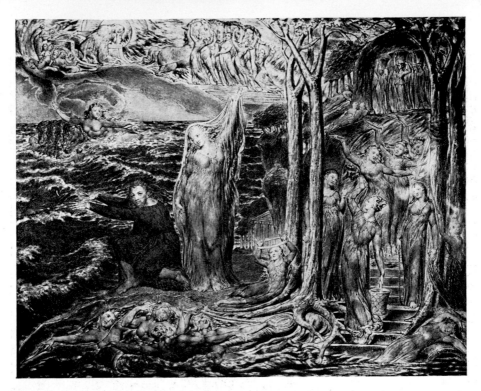

44. The Cycle of the Life of Man, 1831. Tempera on paper. 16 by 19½ ins. *National Trust*

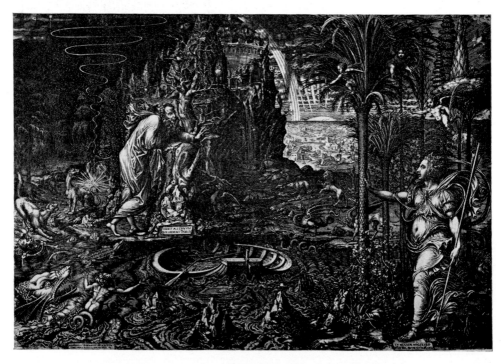

45. Raphael's Dream or the Melancholia of Michelangelo, by Giorgio Ghisi (*c.* 1520–82). Line engraving. 14$\frac{9}{10}$ by 21$\frac{1}{5}$ ins. *P. and D. Colnaghi and Co. Ltd*

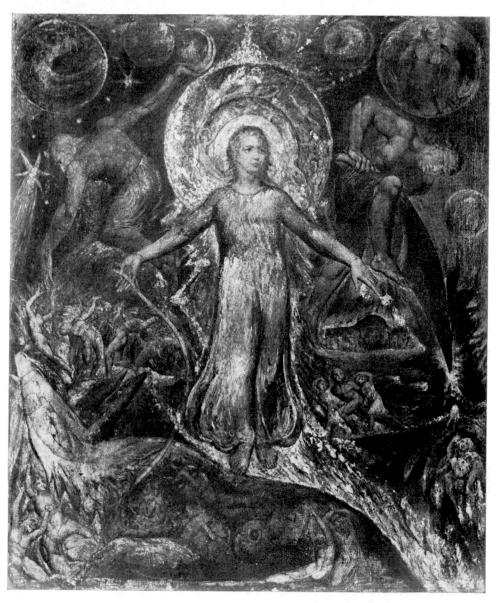

46. The Spiritual Form of Pitt Guiding Behemoth, ?1805.
Tempera on canvas. 29⅛ by 24¾ ins. *Tate Gallery*

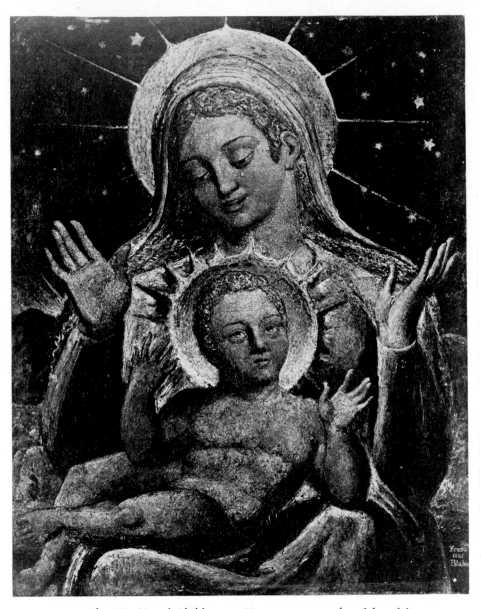

47. The Virgin and Child, 1825. Tempera on panel. $11\frac{1}{4}$ by $9\frac{1}{4}$ ins.
Mr. and Mrs. Paul Mellon

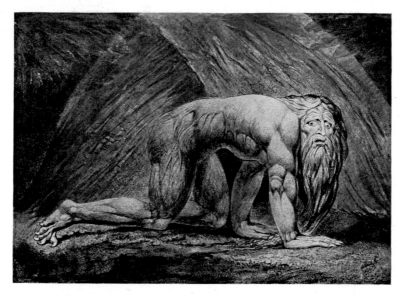

48. Nebuchadnezzar, 1795. Colour-printed drawing. 16$\frac{15}{16}$ by 23$\frac{3}{4}$ ins. *Tate Gallery*

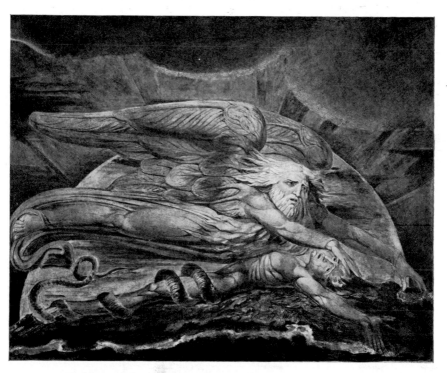

49. Elohim creating Adam, 1795. Colour-printed drawing. 17 by 21$\frac{1}{8}$ ins. *Tate Gallery*

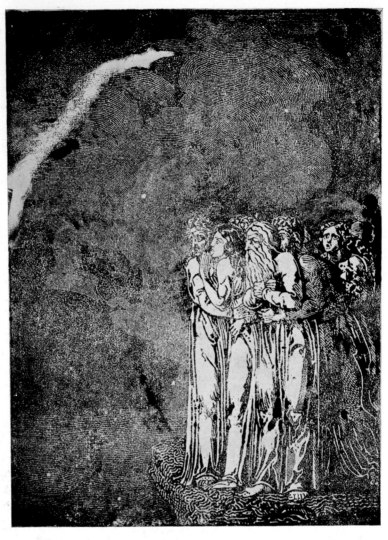

50. The Approach of Doom, after Robert Blake, ?*c.* 1788. Relief-etching. $11\frac{3}{5}$ by $8\frac{1}{4}$ ins. *British Museum*

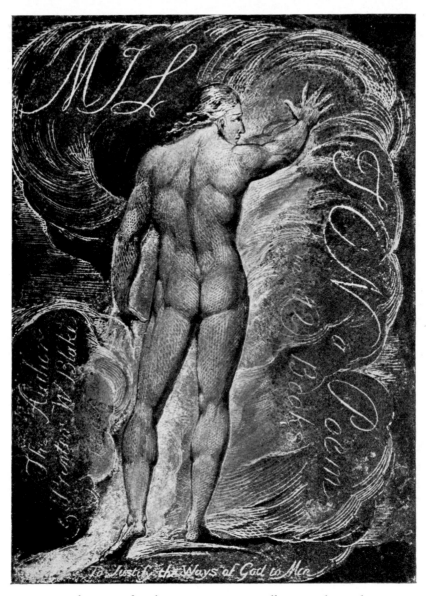

51. Title-page of *Milton: A Poem*, 1804. Illuminated woodcut on pewter. $6\frac{5}{16}$ by $4\frac{3}{8}$ ins. *Lessing J. Rosenwald Collection, Library of Congress*

But I wander on the rocks
With hard necessity

6. Where is my golden palace
Where my ivory bed
Where the joy of my morning hour
Where the sons of eternity singing

7. To awake bright Urizen my king.
To arise to the mountain sport,
To the hills of eternal valleys.

8. To awake my king in the morn:
To embrace Ahanias joy
On the breath of his open bosom:
From my soft cloud of dew to fall
In showers of life on his harvests.

9. When he gave my happy soul
To the sons of eternal joy:
When he took the daughters of life
Into my chambers of love:

10. When I found babes of bliss on my beds,
And bosoms of milk in my chambers
Filld with eternal seed
O! eternal births sung round Ahania
In interchange sweet of their joys.

11. Swelld with ripeness & fat with fatness
Bursting on winds my odors,
My ripe figs and rich pomegranates

In infant joy at thy feet
O Urizen sported and sang.

12. Then thou with thy lap full of seed
With thy hand full of generous fire
Walked forth from the clouds of morning
On the virgins of springing joy.
On the human soul to cast
The seed of eternal science.

13. The sweat poured down thy temples
To Ahania returnd in evening
The moisture awoke to birth
My mothers-joys, sleeping in bliss.

14. But now alone over rocks, mountains
Cast out from thy lovely bosom:
Cruel jealousy! selfish fear!
Self-destroying: how can delight
Renew in these chains of darkness
Where bones of beasts are strown
On the bleak and snowy mountains
Where bones from the birth are buried
Before they see the light.

FINIS

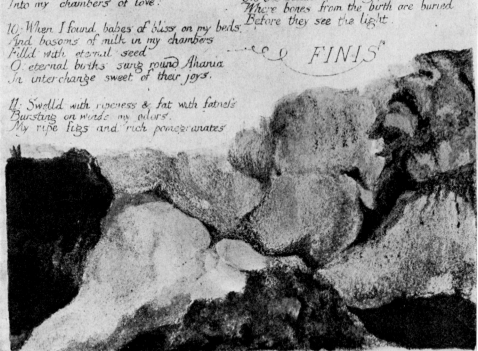

52. Final plate of *The Book of Ahania*, 1795. Intaglio etching and colour printing. 5⅜ by 3⅞ ins. *Library of Congress, Rosenwald Collection*

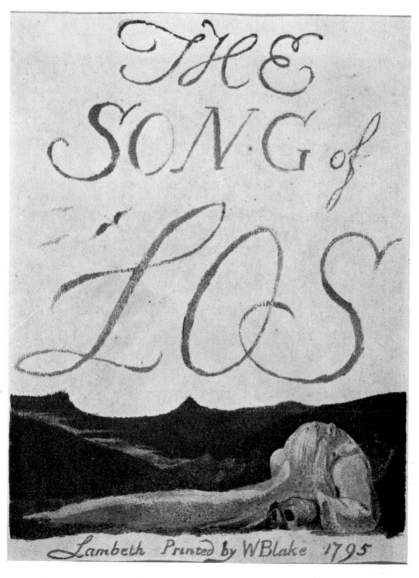

53. Title Page of *The Song of Los*, 1795. Colour-printing. $9\frac{1}{2}$ by $6\frac{7}{10}$ ins. *British Museum*

Are here frozen to unexpansive deadly destroying terrors
And War & Hunting: the Two Fountains of the River of Life
Are become Fountains of bitter Death & of corroding Hell
Till Brotherhood is changd into a Curse & a Flattery
By Differences between Ideas, that Ideas themselves, (which are
The Divine Members) may be slain in offerings for sin
O dreadful Loom of Death! O piteous Female forms compelld
To weave the Woof of Death. On Camberwell Tirzahs Courts
Malahs on Blackheath, Rahab & Noah, dwell on Windsors heights
Where once the Cherubs of Jerusalem spread to Lambeths Vale
Milcahs Pillars shine from Harrow to Hampstead where Hoglah
On Highgates heights magnificent Weaves over trembling Thames
To Shooters Hill and thence to Blackheath the dark Woof! Loud
Loud roll the Weights & Spindles over the whole Earth let down
On all sides round to the Four Quarters of the World, eastward on
Europe to Euphrates & Hindu, to Nile & back in Clouds
Of Death across the Atlantic to America North & South

So spoke Ololon in reminiscence astonishd, but they
Could not behold Golgonooza without passing the Polypus
A wondrous journey not passable by Immortal feet, & none
But the Divine Saviour can pass it without annihilation.
For Golgonooza cannot be seen till having passd the Polypus
It is viewed on all sides round by a Four-fold Vision
Or till you become Mortal & Vegetable in Sexuality
Then you behold its mighty Spires & Domes of ivory & gold

And Ololon examined all the Couches of the Dead.
Even of Los & Enitharmon & all the Sons of Albion
And his Four Zoas terrified & on the verge of Death
In midst of these was Miltons Couch, & when they saw Eight
Immortal Starry-Ones, guarding the Couch in flaming fires
They thunderous utterd all a universal groan falling down
Prostrate before the Starry Eight asking with tears forgiveness
Confessing their crime with humiliation and sorrow.

O how the Starry Eight rejoic'd to see Ololon descended:
And now that a wide road was open to Eternity,
By Ololons descent thro Beulah to Los & Enitharmon,
For mighty were the multitudes of Ololon, vast the extent
Of their great sway, reaching from Ulro to Eternity
Surrounding the Mundane Shell outside in its Caverns
And through Beulah. and all silent forbore to contend
With Ololon for they saw the Lord in the Clouds of Ololon

There is a Moment in each Day that Satan cannot find
Nor can his Watch Fiends find it, but the Industrious find
This Moment & it multiply. & when it once is found
It renovates every Moment of the Day if rightly placed
In this Moment Ololon descended to Los & Enitharmon
Unseen beyond the Mundane Shell Southward in Miltons track

Just in this Moment when the morning odours rise abroad
And first from the Wild Thyme, stands a Fountain in a rock
Of crystal flowing into two Streams, one flows thro Golgonooza
And thro Beulah to Eden beneath Loss western Wall
The other flows thro the Aerial Void & all the Churches
Meeting again in Golgonooza beyond Satans Seat

The Wild Thyme is Los's Messenger to Eden, a mighty Demon
Terrible deadly & poisonous his presence in Ulro dark
Therefore he appears only a small Root creeping in grass
Covering over the Rock of Odours his bright purple mantle
Beside the Fount above the Larks Nest in Golgonooza
Luvah slept here in death & here is Luvahs empty Tomb
Ololon sat beside this Fountain on the Rock of Odours.

Just at the place to where the Lark mounts, is a Crystal Gate
It is the enterance of the First Heaven named Luther: for
The Lark is Loss Messenger thro the Twenty-seven Churches
That the Seven Eyes of God who walk even to Satans Seat
Thro all the Twenty-seven Heavens may not slumber nor sleep
But the Larks Nest is at the Gate of Los, at the eastern
Gate of wide Golgonooza & the Lark is Loss Messenger

54. Plate 39 of *Milton: A Poem*, 1804. Illuminated relief-etching.
5⅝ by 4⅜ ins. *Library of Congress, Rosenwald Collection*

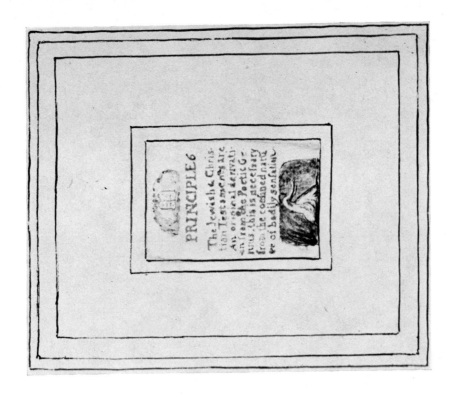

56. *Principle 6 from* All Religions are One. *Relief-etching.*
$2\frac{1}{8}$ *by* $1\frac{3}{8}$ *ins.* Henry E. Huntington Art Gallery

55. Electrotype of original copper plate for 'Nurse's
Song' from *Songs of Innocence.* Fitzwilliam Museum

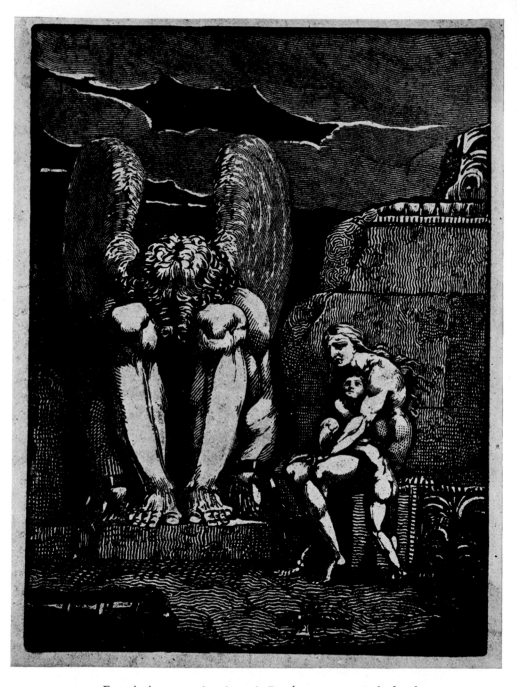

57. Frontispiece to *America*: *A Prophecy*, 1793. Relief-etching.
$9\frac{3}{16}$ by $6\frac{11}{16}$ ins. *Private Collection*

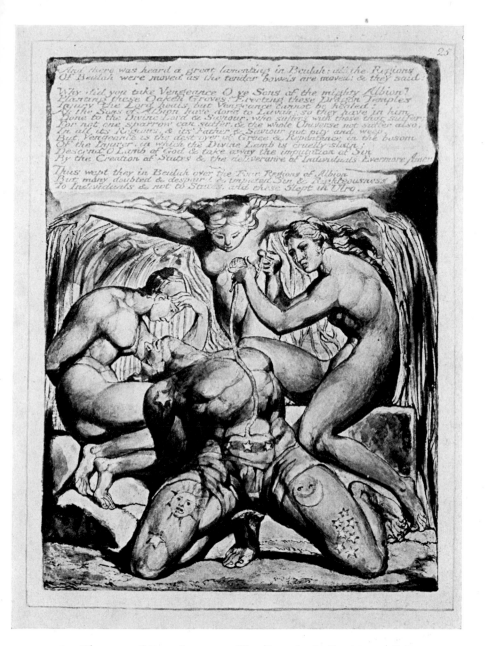

58. Plate 25 of *Jerusalem*, 1804. Illuminated relief-etching. $8\frac{7}{10}$ by $6\frac{3}{10}$ ins. *Mr. and Mrs. Paul Mellon*

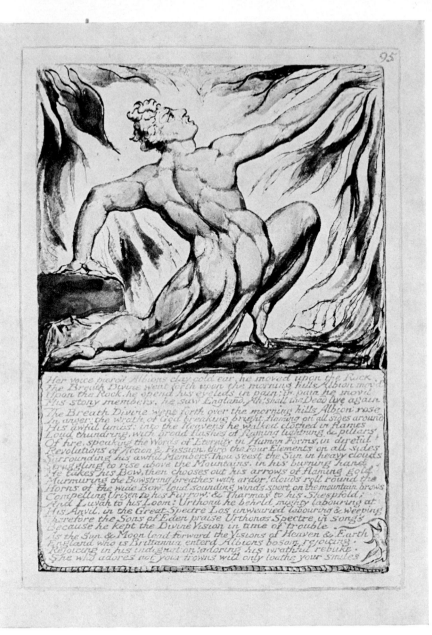

59. Plate 95 of *Jerusalem*, 1804. Illuminated relief-etching. $7\frac{7}{8}$ by $5\frac{7}{16}$ ins. *Mr. and Mrs. Paul Mellon*

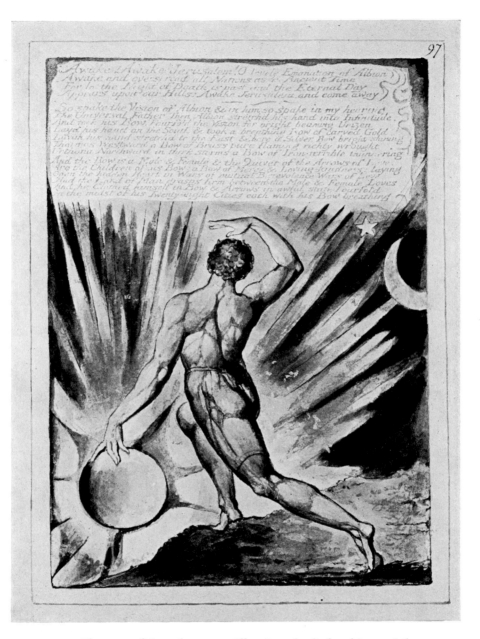

60. Plate 97 of *Jerusalem*, 1804. Illuminated relief-etching. 8 3/16 by 5 13/16 ins. *Mr. and Mrs. Paul Mellon*

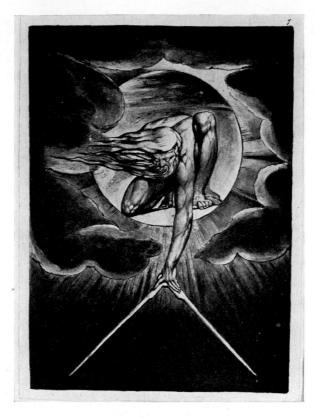

61. Frontispiece to *Europe: A Prophecy*, 1794. Relief-etching.
9⅛ by 6⅝ ins. *Fitzwilliam Museum*

62. Frontispiece to *There is no Natural Religion, c.* 1788. Illuminated
relief-etching. 2¹⁄₁₆ by 1½ ins. *Library of Congress, Rosenwald Collection*

63. Plate 41 of *Jerusalem*, 1804. Illuminated relief-etching. 8$\frac{11}{16}$ by 6$\frac{5}{16}$ ins. *Mr. and Mrs. Paul Mellon*

64. 'Mirth', First State, *c.* 1816. Chalk engraving and stipple. $6\frac{5}{16}$ by $5\frac{3}{16}$ ins. *British Museum*

65. 'Mirth', Second State, 1820. Line engraving and stipple. $6\frac{5}{16}$ by $5\frac{3}{16}$ ins. *Sir Geoffrey Keynes*

66. Christian Reading in his Book, from the *Pilgrim's Progress* series. Water-colour. *Frick Collection, New York*

for the 15 Century, when real energy of mind gained the appropriate rapidity of hand, and when the Vehicle, if not such as he invented was in much better command for sublime compositions. There might have been some variation in the Vehicle, that was enough to make all the difference, & that Vehicle might have been such an one as he would not have complained of. The Author has seen pictures of Blakes in the possession of Wm.[46] Butts Esqr.e Fitzroy Square, that have appeared exactly like the old cabinet pictures of the 14 & 15, Century where he has touched the lights with white compound of whiting & glue, of which material he laid the ground of his Panel. . . . Blake painted on Panel or canvass covered with 3 or 4 layers of whitening & carpenters Glue [perhaps made from rabbit-skin]; as he said the nature of Gum was to crack, for as he used several layers of colour to produce his depths, the Coats necessarily in the deepest parts became so thick, that they were likely to peel off. Washing his Picture over with glue in the manner of a Varnish, he fixed the Colours, and at last varnished with a white hard varnish of his own making. It must however be confessed that his pictures mostly are not very deep, but they have an unrivalled tender brilliancy.[47]

A further, similar description is given by J. T. Smith in *Nollekens and his Times*:

[Blake's] ground was a mixture of whiting and carpenter's glue, which he passed over several times in thin coatings: his colours he ground himself, and also united them with the same sort of glue, but in a much weaker state. He would, in the course of painting a picture, pass a very thin transparent wash of glue-water over the whole of the parts he had worked upon, and then proceed with his finishing. . . . Blake preferred mixing his colours with carpenter's glue, to gum, on account of the latter cracking in the sun, and becoming humid in moist weather. The glue-mixture stands the sun, and change of atmosphere has no effect upon it. Every carpenter knows that if a broken piece of stick be joined with good glue, the stick will seldom break again in the glued parts.[48]

The main difference between Blake's 'fresco' and ordinary tempera lies in his use of carpenter's glue instead of the usual egg yolk. To this may probably be attributed the premature darkening of many of these works.

As to his painting surface, Blake used many different materials:

46. For Thomas. 47. *Life of Blake, Blake Records*, pp. 515, 517.
48. 2nd edn 1829, Vol. II, pp. 487-88.

E

canvas, wood (including mahogany), fine linen, copper and paper. Of the thirty-one tempera panels listed by Sir Geoffrey Keynes,[49] twenty are on canvas, four on wooden panels, one on fine linen and three on copper. The remaining painting by Blake in this list is not tempera, but a varnished water-colour. One more was painted on canvas by Mrs Blake, and yet another was painted on a mahogany panel by Blake's follower, Edward Calvert. One more, since discovered, is on stiff paper.

Most of these works are quite small; the biggest is 'The Spiritual Condition of Man', painted in 1811; this measures 60 by 48 inches. But that he was prepared to paint larger temperas is evident from a passage in his *Descriptive Catalogue*:

> The Greek Muses are daughters of Mnemosyne, or Memory, and not of Inspiration or Imagination, therefore not authors of such sublime conceptions. Those wonderful originals seen in my visions, were some of them one hundred feet in height; some were painted as pictures, and some carved as basso relievos, and some as groupes of statues, all containing mythological and recondite meaning, where more is meant than meets the eye. The Artist wishes it was now the fashion to make such monuments, and then he should not doubt of having a national commission to execute these two Pictures on a scale that is suitable to the grandeur of the nation, who is the parent of his heroes, in high finished fresco, where the colours would be as pure and as permanent as precious stones, though the figures were one hundred feet in height.[50]

It now seems that Blake was too confident in his 'fresco' technique, for not all of them have stood up to the test of time, having cracked, flaked and darkened, although it has been possible to remedy much of this by skilful restoration.

Of the different kinds of surface, the least successful is copper, to which it was difficult to get the materials to adhere. Blake's friend, John Linnell, gave, in a letter to Gilchrist, further reasons for the impermanence of these works, saying that, 'he laid [the] ground on too much like plaster on a wall. When so laid on to canvas or linen, it was sure to crack, and, in some cases, for want of care and protection from damp, would go to ruin.'[51]

Yet some Blake temperas have survived in their original condition,

49. *The Tempera Paintings of William Blake.*
50. K.565–66. 51. Gilchrist, p. 359.

particularly the great 'Arlington Court' picture, 'The Cycle of the Life of Man' or 'The Sea of Space and Time', executed in 1821 (Plate 44).[52]

This picture was, by good luck, found among some junk on the top of a pantry cupboard at Arlington Court, near Barnstaple in Devonshire, after the death of its last owner, Miss Rosalie Chichester, who had given the property to the National Trust just before. Painted on a very thin gesso ground applied to stiff paper, it is one of the finest of Blake's temperas, and illustrates his use in this medium of the very fine miniature technique in which he was at the same time painting many of his water-colours.[53]

Another extremely interesting point about this picture is the close resemblance of its texture to line-engraving, showing how, even at this period of his life, and in a technique remote from engraving, Blake was still being influenced by the technique of his trade. This picture is by no means the only one in Blake's *œuvre* to show this influence, but it shows it more spectacularly than most. The texture is reminiscent of Giorgio Ghisi's engraving, 'Raphael's Dream or the Melancholia of Michelangelo', after Luca Penni (Plate 45). Indeed, if I may digress for a moment from technique into sources, I think there is a close resemblance in the composition of the two works—the grove of trees on the right, and the sea in each composition; the male figure with outstretched arms in the Blake, the male figure in reversed position in the Ghisi; the female figure with the bucket in the Blake, the female figure with the wand in the Ghisi. Surely these resemblances are not purely fortuitous. It is possible that Blake had an impression of the Ghisi among his extensive collection of prints, and that he used it as a basis for this work.

Blake heightened a number of his temperas with gold, thus further enriching an already rich surface. A splendid example of this is 'The Virgin and Child' (1825), in which the heads of both Virgin and Child are surrounded by gold nimbuses (Plate 47). Moreover, many of the highlights, including those on the tears on the Virgin's cheeks, are indicated by gold. This, combined with the dominant reds and blues, gives an incredibly rich effect. Gold is used with equal success in 'The Spiritual Form of Pitt guiding Behemoth' in The Tate Gallery

52. A preliminary drawing of the subject is in the Pierpont Morgan Library.
53. Another tempera with a finely stippled surface is 'Satan smiting Job with boils' in the Tate Gallery.

(Plate 46). Sometimes he attempted to simulate silver by painting a blue wash colour over a gold ground, as on his tempera (now lost) of 'The Last Judgment'.[54] However, the effect of this would have been a greenish tone, rather than silver.

Gold is available in three forms, each of which appears to have been used by Blake. First there is gold leaf, which consists of $3\frac{1}{2}$ inch squares of the metal beaten to microscopic thickness, so thin as to make it almost transparent. To be exact the leaves are 1/300,000 inch thick, and there are 2,000 of them to an ounce. It is issued in books of twenty-five pieces, each between leaves of tissue paper. Blake would have applied this by the method known as water gilding, in which the surface to be gilded is prepared with a gesso consisting of Armenian bole (a smooth red earth), water and glue. Glair was sometimes used instead of glue. The leaf is laid on a gilder's cushion and a piece is cut with a gilding knife, rather bigger than the actual size of the area to be gilded, and is then picked up with a gilder's tip and placed on the gesso, which the artist has dampened by breathing on it. The gold is pressed into place (not rubbed) with a wad of cotton. When it is dry, superfluous gold around the area is brushed away. Finally, if a high finish is required, the gold is burnished with an agate, flint or dog's tooth set in a handle. This form of gilding is a highly skilled process from start to finish, and the foregoing is but an outline of the basic procedure, nothing having been said of attendant difficulties.

Shell gold is powdered gold leaf mixed with honey and ox-gall and sold in mussel shells, or in larger blocks set in porcelain pans. It is applied like water-colour, by taking up a little on a wet-brush. It is best applied by stippling. Gold powder is mixed with honey by the artist himself, and applied in the same way as shell gold.

On a finished picture, the difference between applications of leaf and shell gold or gold powder is best assessed by the density of the surface. Thus, shell or powder gold appears in stipple, or like grains, whereas leaf usually gives a solid and continuous surface, and more-over, if the gesso foundation has been thickly applied, is sometimes slightly raised from the remainder of the surface. Passages of each kind are present in both 'The Virgin and Child' and 'The Spiritual Form of Pitt'.

One of the most original of Blake's temperas is the small panel ($8\frac{7}{8}$ by $6\frac{3}{8}$ inches), 'The Ghost of a Flea' (Plate II). Incidentally, this

54. Smith, *Nollekens and his Times*, Vol. II, p. 480.

also is heightened with gold. But in the present context the most interesting thing about it is the glowing colour, reminiscent of some of the brilliant effects in miniatures in illuminated MSS., and perhaps achieved to some extent by Blake by mixing gold powder with his pigments.[55] The combination of this with the gold highlights, is reminiscent, for example, of Jean Bourdichon's miniature of St Marguerite and the dragon in The Book of Hours of Anne of Brittany,[56] or, some of those in *Le Livre du Cœur d'Amour Épris du Roi René*.[57] So once again we may perceive Blake's preoccupation with miniatures and, at the same time, with the broader aspect of mediaeval art, a preoccupation that had stayed with him ever since he copied monuments in Westminster Abbey during his apprenticeship.

55. Such effects are present in the temperas 'Count Ugolino with his sons and grand-sons in prison' (1827; collection of Sir Geoffrey Keynes), 'Satan smiting Job with boils' (c. 1825; Tate Gallery), and 'The Body of Abel found by Adam and Eve' (? c. 1825; Tate Gallery). These three works are additionally interesting in that Blake incised his signature through the pigment to the underlying gesso, instead of inscribing it.

56. Bibliothèque Nationale (Manuscrit latin 9474). Reproduced in colour in *Les Heures d'Anne de Bretagne*, Editions Verve, Paris, 1946.

57. Library of Vienna. Reproduced in colour in *Verve*, Vol. VI, No. 23, Paris, 1949.

4

Colour-printed Drawings

ONE group of works by Blake, executed in an elaborate hybrid technique evolved by himself, deserves separate consideration. These are usually known as colour-printed drawings, an unsatisfactory term, for they are not really drawings and are only partly colour-printed. They are in fact a development of the monotype, in which a design is painted on a sheet of metal, glass, wood or other smooth surface, and transferred to a sheet of paper by rubbing or rolling the back of the paper on the plate or subjecting them to pressure in a printing press.

But however they are defined, they represent a watershed in Blake's artistic and technical development. They were developed during the 1790's, although he was still offering specimens for sale in 1818.[1] The majority of them seem to have been made in 1795.

There is still some doubt of exactly how Blake worked in this process. The earliest description of it was given by Frederick Tatham, and is described by him in the last paragraph of Gilchrist's *Life*:

> Blake, when he wanted to make his prints in oil, took a common thick millboard and drew, in some strong ink or colour, his design upon it strong and thick. He then painted upon that in such oil colours and in such a state of fusion that they would blur well. He painted roughly and quickly, so that no colour would have time to dry. He then took a print of that paper, and this impression he coloured up in water-colours, repainting his outline on the millboard when he wanted to take another print. This plan he had recourse to, because he could vary slightly each impression; and each having a sort of accidental look, he could branch out so as to make each one different. The accidental look they had was very enticing.[2]

1. Letter to Dawson Turner, 9 June 1818, K.867. 2. Gilchrist, p. 366.

Dante Gabriel Rosetti, who wrote the last chapter of the *Life*, comments: 'Objections might be raised to this account as to the apparent impracticability of painting in water colours over oil; but I do not believe it would be found so, if the oil colour were merely stamped, as described, and left to dry thoroughly into the paper.'[3]

He might have added that Blake would not have used oil colour—we have seen evidence of his objection to that in Chapter 3—but would have used his preferred tempera with probably a glue medium, or perhaps glair. Further, though Tatham was right in saying that Blake could vary each impression, he should have added that he applied the tempera colours only once to the millboard, and that he pulled usually three impressions, each one becoming weaker than the previous one, and therefore requiring a progressively greater amount of finishing and retouching, this being the factor which accounted for the greatest variations.[4]

The limitation in the number of impressions it was possible to take seems to suggest that Blake was less interested in the process for its reproductive possibilities, than for the interesting and beautiful textures it could impart to his work.[5]

The general texture, a reticulated, mottled or granulated surface, reminiscent of aquatint, may have been imparted by the surface of the millboard. But I am not at all sure that Blake used millboard exclusively, if at all, for the effect could have been obtained from a sheet of zinc or copper, being caused by the paint tending to adhere slightly to the plate as it was withdrawn. I have obtained the same granulated effect by painting a design in water-colour mixed with ox gall on a sheet of zinc, placing a sheet of soft Japanese paper on it, and moving a rubber roller over its upper face.

The fact that the same mottled effect often appears on the outlines of impressions taken from the relief-etched plates of the illuminated books seems to suggest that it is a peculiarity of prints taken from a flat metal surface. Also it would have helped to have a metal plate,

3. Ibid.
4. See Butlin, Martin, 'The Bicentenary of William Blake', *The Burlington Magazine*. Three impressions of the colour-printed drawing 'Elijah and the Fiery Chariot' (now known as 'God judging Adam') are compared by means of one of its details. In one, presumably the first to be pulled, the back legs of the horse are defined by printing alone, in another they are less clear; in a third, presumably the last to be pulled, the outline is firmly drawn in ink. Cf. Butlin, 'The Evolution of Blake's Large Colour Prints of 1795', *William Blake Essays for S. Foster Damon*, p. 110.
5. Butlin, *Tate Gallery Catalogue*, p. 34.

which could have been kept warm, in order to keep the paint liquid. In any case, it is probable that millboard would have given a less regular, coarser kind of mottling, and would in any case have been too absorbent to keep the colour sufficiently moist for transfering to the print. Against this, of course, we have the testimony of Tatham, who knew Blake, and who mentions millboard. But Tatham was not born when Blake was working on the colour-printed drawings in the 1790s, and he could hardly have known anything from first-hand knowledge.

Figure 2. Chinese Colour-printer's Work Table. From *Chinese Colour Prints from The Ten Bamboo Studio* by Jan Tschichold (London, 1970). By permission of the author.

I think it is likely that Blake used a similar method to my own, described above, but doubtless fixing his paper more securely before transferring the impression. In this he may have used a method similar to that employed by Chinese woodcut printers. These craftsmen had a bench with a slot in the middle; the paper to be printed is carefully trimmed and then, in a small pile near the slot, held firmly along one edge by a batten of wood, the leaves lying over the batten. On the other side of the table, beyond the slot, the block is placed, together with the printer's tools and ink (Figure 2). The block is inked, one of the leaves is brought over on to its surface, and an impression of the inked surface is transferred by rubbing or rolling the back of the paper. The leaf is then allowed to hang through the slot, and a new

leaf is brought over for printing. This enables prints to be made in several successive colours without difficulties with register, as the sheets are held in a constant position, and the blocks may all be similarly placed on the table if the position of the first one is marked. It is possible that Blake printed in this way, in stages, applying each colour separately on to the board or metal plate.

After printing, the surface was worked up, often with great and painstaking elaboration, by water-colour and ink, sometimes rapidly, while the printed colour was still wet, so as to obtain the maximum subtlety from blending one colour and another. Naturally mottling is absent from areas so worked. In other places, some parts are printed with outlines only, details being added in water-colour.

Another possibility was suggested to Laurence Binyon by the artist Lucien Pissarro, who described a method used by his father Camille Pissarro for making monotypes. This consisted of laying over the first outline print a sheet of glass, presumably cut to the same size to ensure accuracy of register. The colours were then painted on to the glass, closely following the contours of the design. The colour could then have been transferred to a sheet of millboard or metal, again of the same size, the glass removed, and the sheet laid on to the print to transfer the colour.[6]

In all Blake created twelve different subjects in this medium, but the process was also applied to some plates from the illuminated books (see Chapter 5). A few of the latter, with one or two other engravings, were made up by Blake into sets, and bound up, some as a *Large Book of Designs* and others as a *Small Book of Designs* (about 1794–96). There is a considerable difference between these and the colour-printed drawings proper, as they are colour-printed on the base of impressions from relief-etched plates, instead of being colour-printed from the beginning. Most of them are taken from illustrations that occur without text, but a few colour-printed pages that include text are known (Plate III). Indeed whole books were so coloured; the method was used on every copy but one of *The Book of Urizen*.[7] In *The Song of Los*, the actual illustrations were added in colour-

6. Binyon, *The Engraved Designs of William Blake*, p. 19.

7. Butlin, *Essays for Foster Damon*, p. 113. Sir Geoffrey Keynes owns an impression of Plate 25 of *Urizen*, crudely colour-printed, which seems to suggest, by its crudity, that Blake had intended to work on it while the colour was wet, introducing water-colour as in the colour-printed drawings. The finish of an impression of the frontispiece of *The Book of Ahania* in the same collection appears to confirm this.

printing to a separately etched text—in other words no illustration outlines were etched. Even the writing on the title page is in colour-printing (Plate 53).

Of the twelve true colour-printed drawings, the subjects are: 'Elohim creating Adam' (Plate 49), 'Nebuchadnezzar' (Plate 48), 'Naomi entreating Ruth and Orpah to return to the Land of Moab', 'Lamech and his two Wives', 'Pity', 'Hecate', 'The Lazar House or The House of Death', 'The Good and Evil Angels struggling for Possession of a Child', 'Christ appearing to the Apostles after the Resurrection', and 'Newton'. They are among his grandest visual work.

Of 'Pity' there exists, besides the 'standard' version measuring $16\frac{3}{4}$ by $21\frac{1}{4}$ inches (about the average for all twelve), a small version measuring $7\frac{3}{4}$ by $10\frac{3}{4}$ inches. This is in the British Museum and probably represents an experimental trial of the technique before the larger prints were embarked upon. The designs of 'The Good and Evil Angels struggling for Possession of a Child' and 'Nebuchadnezzar' had each been used about 1790–93 in the illuminated book, *The Marriage of Heaven and Hell*. Apart from these there exists one small early experiment in the medium, a tiny work depicting an estuary, with a tree, a boat and figures. It is printed in five colours, probably after a drawing by Stothard.[8]

So far as large original works were concerned, Blake abandoned the process after 1795. It is possible that he found he could achieve similar effects less laboriously in ordinary water-colour or tempera. Therefore, despite the sublimity of his work in this medium, Blake's output remained limited to the twelve major and one smaller designs mentioned above, and to a lesser extent to the few smaller designs from his illuminated books in which he used it for colouring only.

8. Collection of Sir Geoffrey Keynes. See Keynes, *Blake Poet Printer Prophet*, p. 16.

5

Relief-etching and the Illuminated Books

IN his illuminated books Blake achieved a synthesis of his techniques, for engraving in several forms, water-colour, colour-printing and poetry were all combined to produce some of the most original works of art of all time. In short, they consisted of books written by Blake, printed from plates designed and prepared by Blake, which were then coloured, in varying degrees of elaboration, by Blake and his wife. They are the essential Blake, revealing his message in literature and visual art at the same time.

In itself, the idea of hand-colouring printed books was not original. In the sixteenth century printed books of hours were made, printed partly from engraved metal plates or woodblocks, and partly from moveable type, and sometimes elaborately coloured to give them a resemblance to illuminated MSS. Blake might have developed the idea of his own illuminated books from these old *horae*.

Another possible source for the idea of such books was the emblem book, in which a line or two of poetry was accompanied by an engraving expressing the same, usually esoteric idea. Blake's illuminated books went farther than that, of course, and achieved a real synthesis of poetry and visual art. Nevertheless there is common ground between the two.[1]

Be that as it may, Blake characteristically described the inception of his illuminated books in a different way, as told by Gilchrist, who also adds some details of the way in which Blake set to work on the idea:

1. For an assessment of the relationship of the emblem book to Blake's philosophy, see Mitchell, W. J. T., 'Blake's Composite Art' in *Blake's Visionary Forms Dramatic* (ed. Erdman and Grant), pp. 59–61. For emblem books, see Praz, Mario, *Studies in Seventeenth-Century Imagery*, Rome, 1964, *passim*. Cf. *The Notebook of William Blake*, Erdman and Moore edn.

After intently thinking by day and dreaming by night, during long weeks and months, of his cherished object, the image of the vanished pupil and brother at last blended with it. In a vision of the night, the form of Robert stood before him, and revealed the wished-for secret, directing him to the technical mode by which could be produced a facsimile of song and design. On his rising in the morning, Mrs. Blake went out with half a crown, all the money they had in the world, and of that laid out one shilling and tenpence on the simple materials necessary for setting in practice the new revelation. Upon that investment of one shilling and tenpence he started what was to prove a principal means of support through his future life—the series of poems and writings illustrated by coloured plates, often highly finished afterwards by hand—which became the most efficient and durable means of revealing Blake's genius to the world. This method, to which Blake henceforth consistently adhered for multiplying his works, was quite an original one. It consisted in a species of engraving in relief both words and designs. The verse was written and the designs and marginal embellishments outlined on the copper with an impervious liquid, probably the ordinary stopping-out varnish of engravers. Then all the white parts or lights, the remainder of the plate, that is, were eaten away with *aqua fortis* or other acid, so that the outline of letter and design was left prominent, as in stereotype. From these plates he printed off in any tint, yellow, brown, blue, required to be the prevailing or ground colour in his facsimiles; red he used for the letterpress. The page was then coloured up by hand in imitation of the original drawing, with more or less variety of detail in the local hues.[2]

In one essential—apart from the fact that they were printed—Blake's books differ completely from illuminated MSS., for in those the work was composite, being divided between the scribe or calligrapher, who wrote the text, the *historieur* who painted the miniatures, the illuminator who painted the borders, and the gilder who applied and burnished the gold.[3] Blake, as I have just said, produced everything himself, his only helpmate being his wife, whom he had himself trained, and who also bound the sheets of the books in blue-grey paper wrappers.[4] Not only that, and in this he was unique, in addition to being its

2. Gilchrist, pp. 59–60.
3. A modern artist who created the whole of his illuminated MSS. himself—writing, miniatures, illuminating and gilding—was Albert Cousins. But this was unusual at any time. See Lister, Raymond, *The Illuminator. A Tribute to Albert Cousins*, Cambridge, 1966.
4. Gilchrist, pp. 60–61.

executant he was also the author of the work, some of it containing some of the most sublime poetry in English.

I think there is no doubt that Blake was conscious of the vast potential of his illuminated books, which, in theory, provided him not only with a means to circulate his visionary and prophetic poetry, but at the same time gave him a medium, or group of media, by means of which he could combine it with his designs and thereby give his message a more tremendous impact. But more, such a synthesis of word and visual image must have symbolised for him that new synthesis of man's senses for which he constantly strove in every department of his *œuvre*.

Blake's first works in the medium were executed about 1788—they included the small tractates *There is No Natural Religion* and *All Religions are One* (Plates 62 and 56), and the single plate 'The Approach of Doom' (Plate 50), based on a drawing by his younger brother, Robert. Perhaps this is what Blake meant when he spoke of Robert's form standing 'before him, and revealing the wished-for secret'. Blake often spoke figuratively, and perhaps the fact that he made what is considered by some to be his first essay in the technique of relief-etching[5] from one of Robert's drawings, symbolised for him the revealing vision.

It is in fact probable that Blake had the idea of making such books even before his brother Robert's death in February 1787, for there is a fragmentary passage in the MS. *An Island in the Moon* (about 1784–85), which suggests this:

"—them Illuminating the Manuscript."
"Ay," said she, "that would be excellent."
"Then," said he, "I would have all the writing
"Engraved instead of Printed, & at every other leaf
"a high finish'd print—all in three Volumes folio—
"& sell them a hundred pounds apiece. They would
"print off two thousand."
"Then," said she, "whoever will not have them
"will be ignorant fools & will not deserve to live."[6]

5. Strictly speaking, the term 'relief-etching' should be applied to the process of preparing the block and not to the print made from it which is in effect a print from a line-block and not an etching—i.e. not a proof from an intaglio acid-bitten plate. However, for convenience the term is normally used for the print.
 6. K.62.

Nevertheless, although this might have contained a germ of the idea of Blake's illuminated books, it is likely that he was also poking fun at his friend George Cumberland, who was at about this time experimenting with counter-proofs[7] taken from engraved plates, as described by him in a letter to his brother Richard:

The occasion of my writing today is to send you the enclosed specimen of my new mode of Printing—it is the amusement of an evening and is capable of Printing 2000 if I wanted them—you see here one page which is executed as easily as writing and the cost is trifling, for your Copper is worth at any rate near as much as it cost, besides you are not obliged to print any more than you want at one time, so that if the work dont take you have nothing to do but to cut the copper to pieces, or clean it—but if it does you may print 4 editions, 2000 and then sell the Plate as well . . . A work thus printed can only be read with the help of a looking glass as the letters are reversed—I know that would be none to you or to anyone who reflects & knows that glasses are always at hand—but it will be *none to the crowd* by and by, for we may begin by printing Debates or great news and then they will condescend to the Mirror for information and so discover there is no trouble; however we have a remedy for this defect also, for in printing 20 we can have 20 more right by only taking the impressions while wet, in fact this is only etching words instead of Landscapes, but nobody has yet thought of the utility of it that I know of. The expense of this page is 1/6 [*a specimen was enclosed*] without reckoning time which was never yet worth much to authors and the copper is worth 1/6 again when cut up. In my next I will tell you more and make you also an engraver of this work—til then keep it to yourself.[8]

In the event the sales of Blake's illuminated books fell far short of the sanguine hopes expressed in *An Island in the Moon* or of those expressed by Cumberland for his counter-proofs. Of the twenty different works large and small so produced, only a total of about two hundred and ten still survive, some of which are fragmentary, and that number must represent a very high proportion of those

7. A counter-proof is a reversed impression taken from an ordinary proof before it has dried. Its normal function is to allow the state of the engraved plate to be studied.

8. B.M. Add. MS. 36494 f. 232. See Binyon, *Engraved Designs of Blake*, pp. 10–11; Keynes, Geoffrey, 'Some uncollected Authors XLIV George Cumberland 1754–1848', *The Book Collector*, Spring, 1970, pp. 31–65. A description of Cumberland's process appeared in *A New Review with Literary Curiosities and Literary Intelligence*, ed. by Henry Maty, 1784, Vol. VI, p. 318.

actually made.[9] Even this figure includes a number of posthumous copies printed by Frederick Tatham, into whose possession the plates came when Mrs Blake died in 1831. Altogether some three hundred and sixty-three etched plates were used in the illuminated books.[10]

For the reproduction of his designs Blake used engraving and etching techniques. His method of 'woodcutting on pewter' was used to excellent effect, in particular in *Milton* and *Jerusalem* (Plates 51 and 26), in which the white-line technique gives a distinctly 'visionary' impression, as if the burin had released images previously hidden in the metal surface. Normal intaglio etching was used in the *Book of Ahania* (Plate 52) and *The Book of Los*. But the most characteristic technique of the illuminated books is relief-etching, briefly referred to in the quotation from Gilchrist at the beginning of this chapter. Usually it was used alone, but sometimes was combined with burin work.

There is, in the British Museum, a memorandum book of 1808, which belonged to George Cumberland. It contains two entries, one on each side of a leaf. The first reads, 'Blake N17 South Molton St', which was Blake's address from 1803 to 1821; the second reads, 'Blake's new mode of engraving to be Published by me at his desire.' A later pencil note was added below this, 'He will publish it.' In fact, of course, it was never published and for long Blake's method of relief etching remained a mystery, it being thought that the brief description given by Gilchrist was the right one. But there remained one point which was difficult to explain—no letter in the text ever appeared in reverse. Blake was an experienced engraver, but even a professional, with such a vast body of text to etch or cut in reverse, might be expected to make a mistake here and there. Moreover, it was supposed that Blake had written out the whole text in reverse on the copper plate in a liquid resistant to acid, which would have made the possibility of mistakes even more likely.

The mystery was a challenge to the poet and scholar, Mr Ruthven Todd, who, with the help of the artist, M. Joan Miró, and the engraver, Mr Stanley William Hayter, carried out a number of experiments, and at last arrived at what is now generally accepted to be the solution.[11] Briefly it consisted of writing out the text and drawing the design in

9. Keynes and Wolf, *Census*, *passim*. 10. Keynes, *Blake Studies*, p. 123.
11. Todd, Ruthven, 'The Techniques of William Blake's Illuminated Printing'.

acid-resistant ink, on a sheet, or perhaps separate sheets of paper, then transferring them to the surface of the copper plate by heating the plate, placing the paper with the art-work face down on it, and smoothing the back of the paper with a heated smoothing-iron or roller, after which it could be carefully removed, leaving the ink on the plate. It is probable that in many cases the design was drawn direct on to the plate. The plate was then immersed in acid until those parts around the ink had been bitten away, bubbles that may have gathered being removed by means of a feather. This left the text and design standing bold, so as to provide a printing surface like raised type or a modern photo line-block. In some cases, in particular where there were large expanses of superfluous metal to be removed, Blake probably used an *échoppe*, an oval-pointed engraving or etching tool, to remove it.

It is probably relief etching to which Blake refers in *The Marriage of Heaven and Hell*:

> But first the notion that man has a body distinct from his soul is to be expunged; this I shall do by printing in the infernal method, by corrosives, which in Hell are salutary and medicinal, melting apparent surfaces away, and displaying the infinite which was hid.[12]

So, as I have already observed in connexion with his 'woodcutting on pewter', Blake was using a technique, not only for practical, but for symbolic purposes, corroding with acid the surface of the metal plate, in order that that which was hidden within it could be made manifest.[13] But the symbolism is wider than that, as may be read in the first sentence of the foregoing quotation. Blake considered dualism an illusion, describing the fall of man as 'His fall into Division'.[14] In this way, symbolically, he synthesised poetry and visual art by means of his 'infernal method', showing 'the infinite which was hid'.

It is possible that Blake obtained details of such a technique from a book he is thought to have used as source material for some of his designs—Alexander Browne's *Ars Pictoria: or an Academy treating of Drawing, Painting, Limning, Etching* (2nd edn 1675).[15] This contains

12. K.154.
13. Cf. Eaves, Morris, 'A Reading of Blake's *Marriage of Heaven and Hell*, Plates 17–20: on and under the Estate of the West', *Blake Studies*, Vol. 4, No. 2, pp. 81–116.
14. *Four Zoas*, K.264.
15. Baker, C. H. Collins, 'The Sources of Blake's Pictorial Expression', *Huntington Library Quarterly*, IV, 1941, pp. 360–64. Cf. Mellor, *Blake's Human Form Divine*, p. 284, n.47.

the following passage concerning a method, which, although an intaglio process and therefore not an exact description of the method thought to have been used by Blake, may have suggested to him the idea of his own method, since to reverse it was merely a step.

> Take some *Charcole* and kindle them, then take a *hand-vice* and screw it to the corner of the plate, and hold it over the *fire* till it be warm, then take a piece of *Virgins wax*, and rub it all over the *plate* untill it is covered every where alike; this being done, take a *stiff feather* of a *Ducks wing* that is not *ruffled*, and drive it even and smooth every where alike, and let it coole, then write the *hand* and *letter* which you intend to grave upon the *plate*, on a piece of *paper* with *ungum'd Ink*, then take the *paper* which you have written, and lay that side which is written downwards next to the wax, and fasten the four *corners* with a little *soft wax*, but be sure to place the writing so, that the lines may run straight, then you must take a *Dogs Tooth*, and rub the *paper* all over which is *fastened*, and not miss any place; this being done, take off the paper from the *plate* and you shall see the very same Letters which you wrote on the paper hath left their *perfect impression* upon the *wax*, then take a *Stift* and draw all the Letters through the wax upon the *plate*, and when you have done that, warm the *plate*, and take a *linnen rag* and rub the wax clean off, and you shall see all the Letters drawn upon the Copper, then get some good *French Gravers* and grind them, as they should be very *sharp* towards the points upon a *Grind-stone*, and after wards whet them very smooth and sharp upon a good *Oyl stone*, then *Grave* the Letters with them.[16]

But although there are obvious reasons for believing that Blake might have found inspiration for his method in Browne's work, it is described in other works also, and Blake could have taken details from any one of them. One such is William Salmon's *Polygraphice or The Arts of Drawing, Engraving, Etching. . . .*[17] A closely similar method is described in *The Handmaid to the Arts* by Robert Dossie.[18] Yet another description of a similar process was published in Blake's own day, after he had been using relief etching for years. It was by William Home Lizars, an engraver who executed some plates for Audubon's *Birds of America*, and was published in the *Edinburgh Philosophical Journal*[19] under the title, 'Account of a new style of Engraving on

16. p. 108. 17. 8th edn, 1701, p. 83. 18. 2nd edn, 1764, Vol. II, pp. 102 et seq.
19. June–October 1819. Reprinted in *Gentleman's Magazine*, 1821, pp. 625–27. Cf. Keynes, *Blake Studies*, p. 246.

F

Copper in Alto Relievo, invented by W. Lizars'. In this case the design was drawn direct on to the copper with a pencil or pen, using turpentine as a medium, and then etched, so that the design was left in relief. Apparently it was also used on stone, for Lizars wrote, 'Mr. Sieveright of Meggetland, a gentleman well known in this city for his scientific acquirements, and to whom, during these experiments, I was much indebted, used with very great success the same kind of limestone which is employed in Lithography.'

The method described by Browne and others seems to have given rise to a memorandum by Blake, written in 1807:

To Woodcut on Copper: Lay a Ground as for Etching; trace &c, & instead of Etching the blacks, Etch the whites & bite it in.[20]

This represents, so to speak, a stage on the way towards relief-etching, and the next stage was to find some means of transferring the whole design, instead of laboriously reversing it line by line.

The experiments conducted by Mr Todd and his associates led to the use of a piece of paper coated with gum arabic and soap, to which the text of a poem was applied in a stopping-out mixture consisting of two parts asphaltum to one part resin in benzine. The paper was soaked and laid face down on a heated copper plate and great pressure was applied from a roller, after which the back of the paper was rubbed all over with an agate burnisher. The paper was again soaked and removed, and the reversed lettering in the stopping-out mixture remained on the plate, the paper itself being left blank. Designs were drawn on the plate by M. Miró, and it was then ready for biting in a bath of diluted nitric acid (one part acid to two parts water). This does not, like sulphuric acid, bite under the raised parts if immersed for relatively long periods for deep biting.

It is probable that Blake worked in exactly this way, that is, to transfer the text, and then to paint the design directly on to the plate. To have worked in the opposite way, first painting the design on the plate, and then transferring the text, might have led to the design being smudged. To have transferred everything, text and design, would have been unnecessary; the labour of working in reverse on the decorative or illustrative parts would have held no terrors for a professional engraver like Blake; but to have written out in reverse the

20. K.440.

hundreds of lines in the texts would have been tedious, even for him. On the other hand, small decorative motifs among, or peripheral to, the text, were almost certainly part of the transfer (Plate IV).

In one place, Blake used two separate plates to print one page. This was Plate I of *America*, which is headed by the word PRELUDIUM. This word was usually printed from a small separate plate, as is proved by slight variations in its position relative to the rest of the design. But in one case it was painted instead of printed.

Only one fragment remains of Blake's relief-etched plates, a small portion of a cancelled plate from *America*.[21] This is, however, particularly interesting in illustrating the attention Blake gave to details of technique, for the lowered parts of the plate, bitten away by the acid, have been highly burnished, so that superfluous ink would not be trapped in them. In addition there are some electrotypes taken from the original plates of *Songs of Innocence and of Experience* for the first editions of Gilchrist's *Life of Blake*, published in 1863 (Plate 55). Gilchrist recalled that: 'In 1863 there remained, out of the destruction that had engulfed so large a portion of Blake's copperplates, ten plates, making sixteen impressions (a few having been engraved on both sides) of the *Songs of Innocence and of Experience*. The gentleman from whom they were obtained had once the entire series in his possession; but all save ten were stolen by an ungrateful black he had befriended, who sold them to a smith as old metal.'[22]

Alas! Those ten have also disappeared. But the electrotypes which had been made from them were discovered in 1926 at the premises of the firm which had printed Gilchrist's *Life*. As on the originals, there were sixteen designs on ten plates. Three sets of duplicates of the electrotypes were made between 1942 and 1947; one set was deposited at the Fitzwilliam Museum, another at the Victoria and Albert Museum, and a third at the Trianon Press, Paris, which produces the facsimiles published by the William Blake Trust.[23]

According to Gilchrist, Blake 'despised etching needles, and worked wholly with the graver in later years'.[24] But, as we have just seen, Blake's method of relief etching would not have called for much, if any, work with the needle, the text and design being written out or

21. In the Lessing J. Rosenwald Collection. 22. Gilchrist, p. 105.
23. Keynes, *Blake Studies*, Chapter XVI. The William Blake Trust facsimiles are listed in the Bibliography in the present work.
24. Gilchrist, p. 360. But cf. p. 21 of this book.

painted in stopping-out mixture. Moreover, as shown on the electro-
types for the *Songs* and in certain impressions from various books,[25]
he made corrections or additions by the burin. In any case this would
be the easiest way to make alterations to relief blocks. Theoretically,
alterations could be made by etching, but it would be infinitely more
laborious and, in view of the remark in Gilchrist it seems that Blake
would in any case have preferred to work with the burin. This is
certainly not surprising in one whose trade was engraving.

There is one big advantage in printing from a relief etching, in that
it requires less pressure than would be necessary to force the damp paper
into the lines of an ordinary etched or engraved plate, in order to
pick up the ink. A special etching press is therefore not required.

Nevertheless, there are problems in inking, but these very problems
helped to give Blake's work one of its most characteristic effects—
that mottled colour which we have already noted on the colour-
printed drawings. Inking by a rubber or gelatine roller tended to force
ink into the bitten or gouged parts of the plates, which would have
given a blurred, untidy print. Blake consequently used the same
inking method that he used for his colour-printed drawings. In other
words, a plain plate or board was inked, and, under slight pressure,
was placed face-downward on the relief-etched plate, transferring to
it a thin but adequate layer of colour, without its being forced into
the lowered parts. It was then ready for printing.

Sometimes Blake varied the colour of the printed plate from one
part to another; this could be done with ease by his method of inking,
although the same effect could have been accomplished *à la poupée*.
But usually he printed in a single colour—blue, brown-green, olive-
green, blue-green, grey-green, red-brown, olive-brown, golden-
brown, orange, orange-red, brick-red, grey, black or sepia, each of
which shows considerable variations from book to book, and even
from page to page. Sometimes framing lines of indian ink, orange-red
or some other colour, were added around the whole design, and
sometimes Blake numbered by hand the pages or leaves in a similar,
or perhaps contrasting colour to the frame lines. In one copy of
Milton, now in the British Museum, he painted a complete border
round one of the plates (No. 30).

In places, here and there, Blake strengthened weak lines or lettering
(probably caused by imperfect biting in the acid bath), by pen and ink

25. *Blake Newsletter*, VI, p. 47.

or brushwork. In its simpler form this merely involved addition to or strengthening of etched lines, as, for instance, on the vignette at the foot of Plate 9 (principle 6) of *All Religions are One* (Plate 56).[26] It is, however, especially true of later impressions of the illuminated books, where the colouring is also more elaborate than in the early ones. In some cases he added considerable detail to the etched background. In copies of *The Book of Thel*, for example, clouds and other details were added during colouring.[27]

One characteristic of many of Blake's relief-etched plates is that which is sometimes called 'thumb-print' lines, from the involuted, convoluted or roughly parallel lines which, in places, look like thumb prints. Blake might have developed this in part from chiaroscuro woodcuts of the sixteenth century which obtain some of their effect from similar, though somewhat coarser lines.

Laurence Binyon thought that 'thumb-print' lines were perhaps made by 'drawing a comb over the ink-charged plate'.[28] I do not understand what he meant by this, unless it was that Blake was supposed to have coated his plate with stopping-out liquid, and, then to have combed it prior to biting. But apart from the obvious difficulties of proceeding in this way, the lines are not exactly parallel, as they would be if they were drawn or impressed with a comb. I think the explanation is simply that Blake engraved the lines where he was using the 'woodcutting on pewter' technique; as a trained engraver this would have caused him little difficulty. If the plate was being produced by relief etching, he could still have added these effects by engraving blank parts of the plate after the remainder had been etched. Indeed, in his early plate, 'The Approach of Doom' (Plate 50),[29] made in what was the experimental period of the technique, this seems to have been the case, for the figures and the promontory on which they stand, have the coarser detailing that would be expected from a transfer process; while the swirling 'thumb-print' background is finely and sharply handled, as would be expected from burin work.

26. Copy in the Henry E. Huntington Art Gallery, San Marino, California. Facsimile published by The William Blake Trust, 1970.
27. Cf. Bogen, Nancy, *Book of Thel*, pp. 44, 46.
28. *Engraved Designs of Blake*, p. 16.
29. Ibid., pl. 44. British Museum. In passing it may be remarked that E. S. Lumsden in *The Art of Etching* was of the opinion that in this work Blake drew the lines in stopping-out varnish and bit away the metal between them, whereas in *The Man Sweeping the Interpreter's Floor* he coated the plate with ground and removed those parts and lines which he did not wish to print (pp. 111–12).

Another possibility is that after the relief-etched part of the design had been transferred, the surrounding part of the plate was coated with stopping-out liquid, and that Blake scratched or lightly engraved the 'thumb-print' part of the design through that, leaving the acid bath to do the rest.

Similar though not such contrasting differences as those in 'The Approach of Doom' are present in the frontispiece to *America* (Plate 57), and it is probable that similar refinements of technique were used on the illustrations on the broadsheet of Hayley's ballad of 'Little Tom the Sailor' (Plate 27). (The text of this was relief-etched on copper.)

Another important effect in Blake's relief-etching is that of cloisonism, or heavily-outlined passages, as in *cloisonné* enamel, as, for example, on Plates 95 and 97 of *Jerusalem* (Plates 59 and 60). It is yet another manifestation of the bounding line. It was a device later to be used by the French painter, Georges Roualt, and was perhaps derived from lead cames in stained glass. It is extremely effective in throwing up the brilliance of colour in individual passages, an idea strongly developed by Roualt, but somewhat less apparent in Blake's work, who seems to have used it mainly as a general underlying guide for his colouring. For instance, on Plate 25 of *Jerusalem*, the almost brutal outlining that appears in uncoloured impressions, disappears under the softness of Blake's elaborate colouring (Plate 58).

Still, from Blake's use of the idea we may perhaps gain an impression of what his stained glass would have been like had he been given a chance to design it. We know he would have relished such an idea. Samuel Palmer once asked him how he would like to paint on glass, for the great west window of Westminster Abbey, his design in *Job* of 'The Sons of God shouting for joy'. 'He said', wrote Palmer, 'after a pause, "I could do it!" kindling at the thought.'[30]

After Mrs Blake's death, most if not all of Blake's then surviving relief-etched plates passed to Frederick Tatham. Tatham printed a limited number of books from some of these, *Europe, Jerusalem* and *Songs of Innocence and of Experience*, usually in red-brown, orange-brown, grey, sepia or black. These impressions lack the quality of those made by Blake, being hard and flat. It is unlikely that Tatham used Blake's careful method of inking, and the harsh quality of these

30. Lister, op. cit., letter 1855 (4).

posthumous prints is, perhaps, at least partly attributable to the inking being done from a roller.

It is doubtful if, except perhaps when he first began to make them, Blake kept a stock of his books already illuminated. That this was the case at the end of his life is shown by a passage from a letter to George Cumberland, written on 12 April 1827. In the same letter he gives some of his prices for these works:

> You are desirous I know to dispose of some of my Works & to make them Pleasing. I am obliged to you & to all who do so. But having none remaining of all that I had Printed I cannot Print more Except at a great loss, for at the time I printed those things I had a whole House to range in: now I am shut up in a Corner therefore am forced to ask a Price for them that I scarce expect to get from a Stranger. I am now Printing a Set of the Songs of Innocence & Experience for a Friend at Ten Guineas which I cannot do under Six Months consistent with my other Work, so that I have little hope of doing any more of such things. The Last Work I produced is a Poem Entitled Jerusalem the Emanation of the Giant Albion, but find that to Print it will Cost my Time the amount of Twenty Guineas. One I have Finish'd. It contains 100 Plates but it is not likely that I shall get a Customer for it.
>
> As you wish me to send you a list with the Prices of these things they are as follows

	£	s	d
America	6.	6.	0.
Europe	6.	6.	0.
Visions &c	5.	5.	0.
Thel	3.	3.	0.
Songs of Inn. & Exp.	10.	10.	0.
Urizen	6.	6.	0.[31]

The fact that the books were coloured as they were sold enables us to assess the development of Blake's technique as a colourist, not only in this part of his output, but in his painting in general. It is also interesting to note that, as he developed his colour-printed drawings, he stopped for some eight or nine years from making any illuminated books—that is from about 1795 when he produced *The Book of Ahania*, *The Song of Los* and *The Book of Los*, until 1804 when he began work on *Milton*.

We will return to a consideration of colouring shortly, but in

31. K.878.

passing it will be as well to note the development of the size of the
etched areas of the pages in the illuminated books. The first ones,
perhaps because of their experimental nature, are small and simple.
Those of *There is No Natural Religion* measure 5 by 4 cm.[32] and of
All Religions are One 5·5 by 4 cm. (both about 1788) (Plates 62 and 56).
In *Songs of Innocence* (1789), Blake probably felt happier working
in the medium and, confident in his technique, felt able to handle a
larger plate (11 by 7 cm.), which would also have given him a better
expanse in which to develop his designs. *Visions of the Daughters of
Albion* (1793) and *The Marriage of Heaven and Hell* (about 1790–93)
were even bigger—17 by 22 cm. and 16 by 11 cm.—a tendency
maintained in *America* (1793; 24 by 17 cm.), *The First Book of Urizen*
(1794; 16 by 11 cm.), *Europe* (1794; 24 by 17 cm.) and *The Song of
Los* (1795; 24 by 17 cm. to 22 by 14 cm.). In *The Book of Ahania* (1795;
13·5 by 7·5 cm.) and *The Book of Los* (1795; 13·5 by 10 cm.) Blake
returned to a smaller format. But in Blake's last two great illuminated
works, *Milton* and *Jerusalem* (both begun in 1804), he triumphantly
chose once again large formats: 16 by 11 cm. and 22 by 16 cm.

Alongside this development in size was a development in decora-
tion, for not only did he continue to use the type of decoration first
developed in *Songs of Innocence*—text interspersed with filigree or
tendrils, small figures and decorations, with small vignette illustrations
—but he began to introduce full-page designs, like the frontispieces
to *America* and *Europe* (Plates 57 and 61) and many of the pages in
Urizen. This development coincided with that of his colour-printed
drawings, and many of the illuminated books made about 1794–95
were in fact coloured by this process.

Blake produced illuminated books over a relatively long period,
so it is not surprising that his methods of colouring varied. The earlier
books, like *Innocence*, are conceived in light, cheerful colours such as
lemon-yellow, rose madder, cerulean blue and emerald. The books
made during his years at Lambeth are, on the other hand, sombre and
heavy—indigo, dark green, grey, black, purple and crimson pre-
dominating. Later colour tends to be somewhat lighter than that of
the Lambeth period, but darker than the early period; it was, more-
over, much more carefully and minutely finished; and, from about
1815, he often made use of shell gold for his highlights.

32. The measurements given in this paragraph are approximate, varying somewhat
from page to page.

There were other variations also. In the first illuminated books, the colouring was in brilliant washes of water-colour; about 1793 it became heavier and somewhat opaque. Then Blake turned to colour-printing, but mixed it in places with hand-colouring (Plate III). Finally, he turned to hand-colouring again, but made it much more elaborate than before, almost akin to the miniature-like technique of his later water-colours, although he did not go so far as to use stipple.

Yet rules cannot be laid down about the style of colouring to be expected from a particular book, as they were usually coloured for specific customers as they were ordered. Also although the plates for a book, *Songs of Innocence* say, may have been made at a certain date—1789 in the case of *Innocence*—Blake continued to print and colour copies until his last years, and his colouring varied according to the period at which it was done. It also varied, said Gilchrist, according to the payment he received:

The illustrated *Songs of Innocence and of Experience* was issued to Blake's public, to his own friends, that is, at the modest price of thirty shillings or two guineas. From the circumstances of its having lain on hand in sheets, and from some purchasers having preferred to buy or bind only select portions, the series often occurs short of many plates—generally wants one or two. The right number is fifty-four engraved pages.

Later in Blake's life—for the sheets always remained in stock—five guineas were given him, and in some cases, when intended as a delicate means of helping the artist, larger sums. Flaxman recommended more than one friend to take copies, a Mr. Thomas among them, who, wishing to give the artist a present, made the price ten guineas. For such a sum Blake could hardly do enough, finishing the plates like miniatures. In the last years of his life, Sir Thomas Lawrence, Sir Frances Chantrey, and others paid as much as twelve and twenty guineas; Blake conscientiously working up the colour and finish, and perhaps over-labouring them, in return; printing off only on one side of the leaf, and expanding the book by help of margin into a handsome quarto. If without a sixpence in his pocket, he was always too justly proud to confess it: so that whoever desired to give Blake money had to do it indirectly, to avoid offence, by purchasing copies of his works; which, too, might have hurt his pride had he suspected the secret motive, though causelessly; for he really gave, as he well knew, far more than intrinsic equivalent.

The early, low-priced copies—Flaxman's, for instance—though slighter in colour, possess a delicacy of feeling, a freshness of execution, often

lost in the richer, more laboured examples, especially in those finished after the artist's death by his widow. One of the latter I have noticed, very full and heavy in colour, the tints laid on with a strong and indiscriminating touch.

Other considerable varieties of detail in the final touches by hand exist. There are copies in which certain minutiae are finished with unusual care and feeling. The prevailing ground-colour of the writing and illustrations also varies. Sometimes it is yellow, sometimes blue, and so on. In one copy the *writing* throughout is yellow, not a happy effect. Occasionally the colour is carried further down the page than the ruled space; a stream, say, as in *The Lamb*, is introduced. Of course, therefore, the degrees of merit vary greatly between one copy and another, both as a whole and in the parts. A few were issued plain, in black and white, or blue and white, which are more legible than the polychrome examples. In these latter, the red or yellow lettering being sometimes unrelieved by a white ground, we have, instead of contrasted hue, gradations of it, as in a picture.[33]

The work involved in colouring any one of the illuminated books was enormous, becoming steadily more so as Blake's colour schemes became more elaborate. But, dividing his work with Catherine must have led to a large saving, as had been found in practice by trade publishers of hand-coloured prints, such as the 'Penny-plain, Two-pence-coloured' toy-theatre sheets.

In colouring such prints probably as many as six people, perhaps all members of the publisher's family or a group of apprentices, sat around a table, each with a brush in hand, with a coloured specimen before him as a model, applying a single colour to the sheet as he received it, then passing it to his neighbour for the application of a further colour. Although this work was on the whole less highly-finished than Blake's, it probably was virtually the same method as the one used by him, except that in his case the colours would have been shared between two colourists, himself and Catherine.

It is surprising how much speed could be added to the work in this way. One colourist who worked on toy-theatre sheets has described how, with practice, a pair of legs could be coloured without lifting the brush from the paper—an upward stoke for one leg, a downward stroke for another, the stroke being narrowed or widened as necessary. This took about two seconds, about the same time being occupied by

33. Gilchrist, pp. 104–5.

the arms of a jacket, plus four seconds for the rest of the figure, the whole taking some eight seconds. In this way, a sheet of ten characters would take eighty seconds.[34]

One point that had to be observed was, if colours were being super-imposed on others (as was the case in much of Blake's illuminated work), the colour already applied must be allowed to dry thoroughly, otherwise it would mix with the superimposed colour, giving a muddy rather than a translucent effect. Moreover, for the same reason, the superimposed colour would need to have been applied as dry as possible. Indeed, in his more elaborately coloured books, some of Blake's colours are scumbled (i.e. applying a thin coat of opaque or semi-opaque colour over a first application with a nearly dry brush).

I have myself used a similar method to Blake's, using photo line-blocks of drawings of my own as a base for colouring, but one that more closely approaches the finish of Blake's earlier illuminated work. In one work, consciously based on Blake, as I wanted to try out his method in practice,[35] my wife and I shared the colouring as I assumed Blake and Catherine shared theirs. In another,[36] I did all the colouring myself. The amount of detail in each was comparable, but the second one took twice as long to colour. The first one, with the colour shared, containing nine coloured pages, occupied about twelve hours a copy, or about eighty minutes a page. The second one, coloured by myself alone, and containing eleven coloured pages occupied about twenty-four hours a copy, or just over two hours a page.

On the average, the coloured area of the pages is about the same as on those in Songs of Innocence and of Experience, and I would guess that the amount of work in one Blake's earliest copies, but not in his most highly finished style, would represent the same average for a page. Thus, with Catherine helping him, they would have needed, for the fifty-four pages, about seventy-two hours to colour one copy; for which Blake, working alone, would have needed about 110–120 hours. In the most highly-finished copies, like that which belonged to Henry Crabb Robinson,[37] the labour would have been much greater, probably at least three times as great.

34. Speaight, George, Juvenile Drama, London, 1946, pp. 86–88; Wilson, A. E., Penny Plain Two Pence Coloured, London, 1932, pp. 41–42.

35. Virgil's Second Eclogue, Golden Head Press, Cambridge, 1958; limited to twenty-six copies for sale.

36. The Song of Fionnuala and nine other songs by Thomas Moore, Golden Head Press, Cambridge, 1960; limited to twenty-six copies for sale.

37. Facsimile published by William Blake Trust, 1955.

In larger work, like *The Book of Thel* and *America*, the amount of work would have been correspondingly larger, while in the large and elaborately coloured pages of *Jerusalem*—each about four times as large as those in the *Songs*—the amount of work was positively Herculean.

Blake began work on *Jerusalem* about 1804, and completed it about 1818—about fourteen years for the composition of the work. He had completed the colouring when he mentioned the book in a letter to George Cumberland in 1827 (see p. 70), and it would not therefore have been surprising if the colouring, on and off, had occupied a considerable amount of his time during the intervening nine years. We now know that he also coloured another twenty-five pages from the same work, and, of course, he had other work to do in the meantime; but it is obvious that he must have spent an enormous amount of time on the *Jerusalem* sheets. It would not be surprising if he had spent some hours on them during each week of the nine years between 1818 and 1827.

Indeed in the William Blake Trust facsimile of the book,[38] about forty-four separate applications of water-colour were required to colour each full page.[39] In itself this represented an enormous labour, but in the facsimile a stencil process was used which must have eased this somewhat. Such pages in the original would have represented as much effort as that required to produce an elaborately-wrought water-colour of the same size.

Yet, in considering Blake's labour, we must not overlook the help Catherine Blake gave her husband in this side of his work. Frederick Tatham relates how she, 'laboured upon his Works, those parts of them where powers of Drawing & form were not necessary, which from her excellent Idea of Colouring, was of no small use in the completion of his laborious designs. This she did to a much greater extent than is usually credited.'[40]

It should be remembered that Blake's colouring was not merely decorative, although that was one of its functions. For one thing it has definite symbolism, but this is not the place to consider that side of it. What we can, however, consider here is its structural quality, which becomes apparent if an uncoloured page is compared with a coloured one, the former having a flatness that disappears when the qualities of

38. Published 1950.
39. Ibid., Introduction, p. 1.
40. *Life of Blake, Blake Records*, p. 534.

recession and approach possessed by various colours are added, bringing out the moulding of forms, their relative importance, and the quality of space.[41] In this, Blake was following a well-established tradition which had been adapted by early wood-cutters from a method used by mediaeval miniaturists.[42]

If we examine one of Blake's uncoloured plates from the *Songs*, 'Nurse's Song' for instance, it will be appreciated as a fine design, pleasing but lacking depth.[43] Then if we place beside it even an earlier and simply-coloured version, what a transformation takes place! (Plate IV). The green hill is thrown into prominence by the sunset sky behind it, and even the sky itself is given depth by the simple device of running the purplish shades of approaching night into the red and yellow of the sunset. The tree and foreground are tinted with shades of grey, giving moulding and depth to the front of the design. The circle of playing children receives depth from the nearer figures, which are more vividly coloured than those farther away; and the figure of the seated nurse is given shape by the simple device of introducing two shades of purple into her dress. The foliage at the top of the design obtains contrast from the introduction of gamboge into some of the larger leaves.

The foregoing describes a copy coloured about 1794–95, before Blake had brought his colouring to the great elaboration he had evolved by some thirty years later. In the Crabb Robinson copy he follows the same general principles of colouring as in the earlier copy, but it is all more detailed and elaborately wrought. And, instead of gamboge in the upper decorative foliage, he has used green and shell gold, on a rose-coloured background, and in this case the purple of the sky above the sunset (a more reddish purple than in the earlier copy) becomes sky-blue, which is continued in the left-hand and right-hand margin to merge into the rose at the top. The effect is highly plastic and of great richness.

In those cases where Blake has used colour-printing, the underlying design is sometimes hidden by the opaque colouring, so depriving

41. Cf. Bass, Eben, '*Songs of Innocence and Experience* The Thrust of Design', in Erdman and Grant, *Blake's Visionary Forms Dramatic*, pp. 196–213.

42. Cf. Mardersteig, Giovanni, 'The Artist of the Aesop Woodcuts', in *The Fables of Aesop*, Verona, 1973, pp. 264–67.

43. Incidentally, Blake's designs for his illuminated books show how he used the bounding line to tie a composition together. The sinuous lines, weaving in and out of the lettering, and leading from one part of the design to another, bring into order what could without them often have been a fragmented composition.

the design of the bounding line by which Blake set such store. But the effect, especially the granulating to which I have several times referred, is often very beautiful.

An important ingredient in Blake's illuminated books is their lettering, which, while not great calligraphy, is clear and readable, and has considerable character. It comes about halfway between calligraphy and an imitation of printer's type. But it has not met with universal approval. Graily Hewitt, for instance, for long regarded as the doyen of calligraphers, called it 'clear and neat', yet also 'commonplace and undistinguished'.[44] Hewitt based his criticism on the apparently mistaken hypothesis that Blake wrote the etched plates in reverse. He pointed out the difficulties of a right-handed scribe in trying to maintain the character of pen work while working in reverse, claiming that in the process pull strokes become push strokes, with an attendant alteration of character. And he also pointed out how in Plate 3 of *Europe* the heading, 'A PROPHECY', has the 'Y' in reverse, with the thick sloping stroke at the right, which he claimed to be one of the 'careless errors of the worker-backwards'.

Does this, then, throw doubt on Mr Ruthven Todd's researches and conclusions about Blake's methods of relief etching? I do not think so, and am of the opinion that it merely shows a human error on Blake's part in writing out the transfer, in that he, for a moment, forgot that he was working on a transfer and not on an engraved plate, where indeed he would have drawn a Y in this way, so that it should appear the right way round when printed. That he was capable of making such a mistake is proved by the fact that on the frontispiece of *There is No Natural Religion* (Plate 62) he wrote the inscription and his name at the foot of the plate, the right way round—'The Author & Printer W. Blake'—with the result that it was printed backwards. Yet it should not be overlooked that elsewhere (for example, *Jerusalem*, Plate 41 (Plate 63) and *Milton*, Plate 30) Blake reversed his lettering purposely, to give it a symbolic meaning, and he may have done the same here. Sir Geoffrey Keynes thinks it might have been done to indicate that Blake was merely the agent of a higher authority.[45]

There is, though, one other matter that is perhaps not unrelated to

44. Wilson, *The Life of William Blake*, p. 382.
45. 'Description and Bibliographical Statement' in William Blake Trust facsimile of *There is No Natural Religion*. Cf. Bentley, G. E., Jr, *The Blake Collection of Mrs Landon K. Thorne*, p. 20.

this question. This is the fact that, from about 1791 until about 1803, Blake began to put a serif on the left instead of the right of his lower-case g,[46] as if he were cutting that part of the letter with a graver, so that it would print the other way round. That this was a mistake seems proven by the fact that in many cases in his relief-etched plates, he added rightward serifs in brushwork after printing, although he also allowed the leftward ones to remain. In intaglio plates he sometimes corrected the serif by burnishing out the leftward serif and engraving a rightward one instead. Still, it does seem strange that a mistake should have been perpetrated for about twelve years, and it cannot, I think, be denied that Blake either had some special reason for using the leftward g, or that he inexplicably erred on numerous occasions. But a consideration of the whole problem and its ramifications are tremendously complex, and outside our present scope.

Blake's lettering developed over the years in other ways. In *There is No Natural Religion* (*c.* 1788), of which there are two distinct sets of plates, it is mainly Roman, but in series *a*, one plate, 'The Argument', is in script; while in series *b*, some headings and the last plate are in script. Incidentally, the lettering of these plates shows the characteristic thick, leaf-like swash on the descenders of lower case y's that Blake was to employ so widely in the lettering of his illuminated books.[47] *All Religions are One* (*c.* 1788), which almost certainly preceded *There is No Natural Religion*, is written throughout in Roman, as also is *Songs of Innocence* (1789). On the other hand, many plates in *Songs of Experience* (1794) are in slanting lettering, a style Blake had already used, in varying degrees of development in *The Book of Thel* (1789), *Visions of the Daughters of Albion* (1793), *The Marriage of Heaven and*

46. Readers who wish to pursue the problem in detail are referred to Erdman, David V., 'Suppressed and Altered Passages in Blake's *Jerusalem*', *Studies in Bibliography*, 17, 1964. Cf. notes in *Blake Newsletter*, Vol. III, pp. 8–13, 42 (Erdman) and 43–45 (G. E. Bentley, Jr).

47. There seems little doubt that Blake's lettering posthumously influenced some artists, for it may surely be discerned in certain lettering by Dante Gabriel Rossetti and Charles Ricketts. For example, in the lettering under the woodcut designed by Rossetti for Christina Rossetti's *The Prince's Progress and other poems* (1866) the g's all have the extended leaf-like tails typical of Blake's. (There is, however, a slight possibility that they were cut in this way not because they were designed so by Rossetti, but by the craftsman who engraved the block, W. J. Linton. Linton had made wood-engraved copies of various works by Blake for Gilchrist's *Life of Blake* (1863), and presumably might have copied this characteristic.) An exaggerated use of the extended tail to descenders occurs in Ricketts's lettering for Arthur Salmon's 'A Village Maid' (*Magazine of Art*, 1891, p. 115) and for Sir Thomas Wyat's 'The Lover Despairing to Attain' (ibid., 1892, pp. 386–87). I am grateful to Mr David Gould for drawing my attention to this.

Hell (*c.* 1790–93), and *America* (1793). He was to use it again in the remainder of his illuminated books: *The Book of Urizen* (1794), *Europe* (1794), *The Song of Los* (1795), *The Book of Ahania* (1795), *Milton* (1804) (see Plate 54), and *Jerusalem* (1804).

The reason why, after 1794, except for some page headings, Blake dropped Roman lettering from his illuminated books, was, I should imagine, that he found its upright format less easy to write with a pen than the slanting near-Italic, an approximation, no more, to the 'sweet Roman hand' recognised by Malvolio, which lends itself more naturally to the slant of handwriting.

CHRONOLOGICAL TABLE[1]

Year	Biographical Details	Works
1757	William Blake born, 28 November.	
1767	Attends Pars's Academy from this year until 1772. Robert, William's favourite brother, born 4 August.	
1772	Apprenticed to James Basire, engraver, 4 August.	
1773		Engraving, *Joseph of Arimathea among the Rocks of Albion*.
1774		Illustrations to Richard Gough's *Sepulchral Monuments* (issued 1786, 1796).
1779	Apprenticeship ends, August. Admitted student at the Royal Academy, to study as an engraver, 8 October.	
1780	First picture exhibited at the Royal Academy: '315. Death of Earl Godwin'. May. (A sketch in water-colour of the subject is in the British Museum.) Meets, at about this time, Joseph Johnson, publisher and bookseller, who commissioned from him over a number of years, engraved work after other artists, particularly Thomas Stothard. Up to 1806, Johnson published about half of Blake's engravings. Meets John Flaxman the sculptor, Henry Fuseli and George Cumberland at about this time.	*The Dance of Albion*. Designs (see under 1790) Blake's earliest signed commercial engraving 'Fencing 4th position' in J. Olivier's *Fencing Familiarized*.
1782	Marries Catherine Boucher, or Butcher, 18 August.	*Evening Amusement*, stipple-engraving after Watteau (some

1. This is intended only as a general guide for the present book. For a full chronology the reader is referred to Bentley, *Blake Records*.

Year	Biographical Details	Works
1782 (cont.)	Takes up residence at 23 Green Street, Leicester Fields.	impressions in monochrome, some in colours).
1783	Printing of *Poetical Sketches* ~~underwritten by John Flaxman and Mrs Harriet Mathew, wife of the Rev. A. S. Mathew~~	*Poetical Sketches.* *The Fall of Rosamund*, stipple-engraving after Stothard (some impressions in monochrome, some in colours). Engraving for John Hoole's translation of Ludovico Ariosto's *Orlando Furioso*.
1784	Sets up as a printseller at 27 Broad Street, in partnership with James Parker, ~~another former apprentice of Basire.~~	*Zephyrus and Flora*, stipple-engraving after Stothard (some impressions in monochrome, some in colours).
1785	Moves to 28 Poland Street, autumn.	*An Island in the Moon*, MS. *c.* 1784–85. Water-colours of Bible subjects being painted by this time. Experiments in tempera ('fresco') probably begun.
1787	Death of Robert Blake, February. About this time Blake begins to experiment with relief-etching, which he claimed was revealed to him in a vision by his dead brother.	Relief-etching, *The Approach of Doom*.
1788		First results of experiments in relief-engraving completed at about this time, viz., *There is No Natural Religion* and *All Religions are One*. Engraved frontispiece, after Fuseli, for John Caspar Lavater's *Aphorisms on Man*.
1789		*Songs of Innocence.* *The Book of Thel.* *Tiriel* ~~and its illustrations belong to about this time.~~ Engravings for John Caspar Lavater's *Essays on Physiognomy*.

Year	Biographical Details	Works
1790	Moves to Hercules Buildings, Lambeth, autumn.	Line engraving, *The Dance of Albion* completed at about this time, perhaps later.
1790		*The Marriage of Heaven and Hell*, etched about 1790-93.
1791	Meets Richard Edwards the publisher at about this time.	Illustrations to Mary Woolstonecraft's *Original Stories from Real Life*. Illustrations to Erasmus Darwin's *The Botanic Garden*.
1793	Begins to use his *Note-book* ('The Rossetti MS.')	Engravings for Capt. John Gabriel Stedman's *Narrative of a five years' Expedition against the Revolted Negroes of Surinam in Guiana*. *Visions of the Daughters of Albion*. *America, a Prophecy*. *To the Public*. *The Gates of Paradise*.
1794		*Songs of Innocence and of Experience*. *The First Book of Urizen*. *Europe, a Prophecy*. Wood engraving on pewter, *The Man Sweeping the Interpreter's Parlour*.
1795		*A Large Book of Designs*. *A Small Book of Designs*. *The Song of Los*. *The Book of Ahania*. Colour-printed drawings. Illustrations for Young's *Night Thoughts* begun (completed 1796). *Vala* or *The Four Zoas* begun (completed about 1806).
1796		Illustrations to Burger's *Leonora*. Engravings for Cumberland's *Thoughts on Outline*.

*G

Year	Biographical Details	Works
1797		Engravings for Young's *Night Thoughts* published. Water-colour illustrations to Gray's poems begun.
1798		Engravings after Fuseli for Charles Allen's *A New and Improved History of England*, and *A New and Improved Roman History*.
1799		Commences a series of fifty small pictures from the Bible, at a guinea each, for Thomas Butts, ~~clerk in the office of the Commissary General of Musters, whom Blake had known for some years.~~ Re-engraves, on a smaller scale, plates for Erasmus Darwin's *The Botanic Garden*.
1800	Moves to Felpham in Sussex, 18 September, to work under the patronage of William Hayley, ~~the poet and amateur, to whom Blake had been introduced by Flaxman, and who had known of Blake since 1784.~~	Decorations and text for Hayley's ballad, 'Little Tom the Sailor'. Engraving of portrait of John Caspar Lavater.
1801		Miniatures. Engraving, after Fuseli, of portrait of Michelangelo for Fuseli's *Lectures on Painting*. Begins water-colour illustrations for *Paradise Lost* and *Comus*.
1802		Engravings (first series) for Hayley's *Ballads*, and for Hayley's *The Life and Posthumous Writings of William Cowper*.
1803	Involved in an incident during August with a soldier named John Scolfield, ~~which led to a charge of sedition being brought~~	Engravings, after designs by Maria Flaxman, for Hayley's *Triumphs of Temper*.

Year	Biographical Details	Works
1803 (cont.)	~~against Blake~~. Returns to London, September, and takes up residence at 17 South Moulton St.	
1804	Tried for sedition at Guildhall, Chichester, 11 January. Found not guilty.	Milton and Jerusalem begun. Engravings for Prince Hoare's Academic Correspondence.
1805	Engaged to teach Thomas Butt's son, Thomas, at a fee of 25 guineas a year. Robert Hartley Cromek commissions Blake to illustrate The Grave by Robert Blair.	Engravings (second series) for Hayley's Ballads and for The Iliad of Homer. Temperas, The Spiritual Form of Pitt guiding Behemoth and The Spiritual Form of Nelson guiding Leviathan.
1807		Lithograph of Enoch made at about this time.
1808		Designs for Robert Blair's Grave published. Water-colours to Milton's On The Morning of Christ's Nativity made at about this time.
1809	Exhibition of works at the house of his older brother, James.	A Descriptive Catalogue.
1810		Engraving of Chaucer's Canterbury Pilgrims. Second state of the engraving, Joseph of Arimathea among the Rocks of Albion. Tempera, Vision of the Last Judgment.
1811		Tempera, Allegory of the Spiritual Condition of Man.
1815		Engravings for Josiah Wedgwood's catalogue. Engravings for Abraham Rees's The Cyclopaedia.
1816		Water-colours of Milton's L'Allegro and Il Penseroso made at about this time.
1817		Engravings for John Flaxman's Theogony of Hesiod. Water-colours of Illustrations of

Year	Biographical Details	Works
1817 *(cont.)*		*the Book of Job* planned and begun at about this time. Water-colours of *Paradise Regained* made at about this time.
1818	Through their mutual friend, George Cumberland, becomes acquainted with John Linnell, who introduces him to John Varley and other artists, and to Dr Robert John Thornton.	*On Homer's Poetry* [*and*] *on Virgil* (about 1818–22). Revised plates of *For Children: The Gates of Paradise*, which becomes *For the Sexes: The Gates of Paradise*. Stipple-engravings after C. Borkhardt, *The Child of Nature* and *The Child of Art*.
1819		Begins drawings of 'Visionary Heads' for Varley. Tempera, *The Ghost of a Flea*, made at about this time.
1820		*Mrs. Q* [Mrs Harriet Quentin], stipple-engraving in colours after Huet Villiers. Engraving with annotations, *The Laocoön*, made at about this time.
1821	About this time forced to sell his collection of prints, the result of over fifty years of collecting. They are bought by Colnaghi. Moves to 3 Fountain Court, Strand.	Wood engravings for R. J. Thornton's edition of Virgil's *Pastorals*. Tempera, *The Cycle of the Life of Man* (the 'Arlington Court' picture).
1822	Receives a donation of £25 from the Royal Academy, because of his 'great distress'. Given Cennino Cennini's *Trattato della Pittura* by Linnell.	Relief-etching, *The Ghost of Abel* (the stereotype was made in 1788).
1823	Linnell commissions engravings of *Illustrations of the Book of Job*.	
1824	About this time, Linnell introduces Samuel Palmer to Blake. Through Palmer, he becomes acquainted with other members	Helps Linnell with engraving of portrait of Wilson Lowry. Water-colour illustrations of *Pilgrim's Progress*.

Year	Biographical Details	Works
1824 (cont.)	of Palmer's circle, 'The Ancients': Edward Calvert, George Richmond, Francis Oliver Finch, Henry Walter, Welby Sherman, and Arthur and Frederick Tatham.	Begins water-colour illustrations of Dante, commissioned by Linnell.
1825	With Mrs Blake visits Samuel Palmer at Shoreham in Kent.	Engravings of *Illustrations of the Book of Job* published March. Tempera, *The Madonna and Child* ('The Black Madonna').
1826	Visits the Calverts at Brixton.	
1827	12 August, death of Blake. 17 August, buried in Bunhill Fields.	Engravings to Dante (unfinished). Last completed engraving, a card for George Cumberland.

BIBLIOGRAPHY

Baker, C. H. Collins: *A Catalogue of William Blake's Drawings and Paintings in the Huntington Library*, San Marino, California, 1957.

Bentley, G. E. Jr: *The Blake Collection of Mrs Landon K. Thorne*, New York, 1971.
—— *Blake Records*, Oxford, 1969.
—— 'Blake's *Job* Copperplates', *The Library*, 5th series, Vol. XXVI, No. 3, pp. 234–41.
—— *William Blake's Tiriel*, Oxford, 1967.

Bentley, G. E. Jr, and Nurmi, Martin K.: *A Blake Bibliography*, Minnesota, Minneapolis, 1964.

Bindman, David (ed.): *William Blake Catalogue of the Collection in the Fitzwilliam Museum Cambridge*, Cambridge, 1970.

Binyon, Laurence: *The Engraved Designs of William Blake*, London, 1926.

Blunt, Anthony: *The Art of William Blake*, London, 1959.

Bogen, Nancy (ed.): *William Blake, The Book of Thel*, Providence, R.I., 1971.

Burlie, Joseph: 'The Eidetic and the Borrowed Image: an Interpretation of Blake's Theory and Practice of Art', *In Honour of Daryl Lindsay: Essays and Studies* (ed. by F. Philipp and June Stewart), Melbourne, 1964, pp. 110–27.

Butlin, Martin: 'The Bicentenary of William Blake', *The Burlington Magazine*, C, 1958.
—— 'The Evolution of Blake's Large Colour Prints of 1795', *William Blake Essays for S. Foster Damon* (ed. A. H. Rosenfeld), Providence, R.I., 1969.
—— *William Blake, a complete catalogue of the works in the Tate Gallery*, with an Introduction by Anthony Blunt and a Foreword by John Rothenstein, London, 1971.

Easson, Roger R. and Essick, Robert N.: *William Blake: Book Illustrator. A Bibliography and Catalogue of the Commercial Engravings*, Vol. I, Normal, Illinois, 1972 (other volumes to follow).

Erdman, David V. (ed.): 'The Dating of William Blake's Engravings', *Philological Quarterly*, 31, 1952, pp. 337–43.

—— *The Poetry and Prose of William Blake*, with a commentary by Harold Bloom, New York, 1965.
—— *The Illuminated Blake*, New York, 1974.

Erdman, David V., and Grant, John E. (eds): *Blake's Visionary Forms Dramatic*, Princeton, N. J., 1970.

Essick, Robert N.: 'Blake and the Traditions of Reproductive Engraving', *Blake Studies*, Vol. 5, No. 1, pp. 59–103.
—— 'Blake, Linnell and James Upton: An Engraving Brought to Light', *Blake Newsletter*, Vol. VII, pp. 78–79.
—— '*Jerusalem*. 25: Some Thoughts on Technique', *Blake Newsletter*, Vol. VII, pp. 64–66.

Figgis, Darrell: *The Paintings of William Blake*, London, 1925.

Frye, Northrop: 'Poetry and Design in William Blake', *The Journal of Aesthetics and Art Criticism*, September 1951, pp. 35–42.

Gilchrist, Alexander: *Life of William Blake*, London, 1942. Everyman edition, ed. by Ruthven Todd.

Hagstrum, Jean H.: *William Blake, Poet and Printer*, Chicago and London, 1964.

Hayter, S. W.: *New Ways of Gravure*, London, 1966.

Ivins, William M. Jr: *Prints and Visual Communication*, London, 1953.

Keynes, Geoffrey: *Blake Studies*, 2nd ed., Oxford, 1971.
—— (ed.) *The Complete Writings of William Blake*, London, 1966.
—— *Engravings by William Blake, The Separate Plates*, Dublin, 1956.
—— (ed.) *The Note-Book of William Blake*, London, 1935.
—— *The Tempera Paintings of William Blake*, London, 1951.
—— *William Blake Poet Printer Prophet*, London, 1964.
—— *William Blake's Engravings*, London, 1950.

Keynes, Geoffrey and Wolf, Edwin, 2nd: *William Blake's Illuminated Books, A Census*, New York, 1953.

Lister, Raymond: *William Blake. An Introduction to the Man and to his Work*, London, 1968.

Lumsden, E. S.: *The Art of Etching*, London, 1924.

Mellor, Anne Kostelanetz: *Blake's Human Form Divine*, Berkeley, California, 1974.

Paley, Morton D. and Phillips, Michael (eds): *William Blake. Essays in Honour of Sir Geoffrey Keynes*, Oxford, 1973.

Preston, Kerrison (ed.): *The Blake Collection of W. Graham Robertson*, London, 1952.

Roe, Albert S.: *Blake's Illustrations to the Divine Comedy*, Princeton, N.J., 1953.

Rosenfeld, Alvin H.: *William Blake. Essays for S. Foster Damon*, Providence, R.I., 1969.

Russell, Archibald G. B.: *The Engravings of William Blake*, London, 1912 (reprint, New York, 1968).

Ryskamp, Charles: *William Blake Engraver: A Descriptive Catalogue of an Exhibition*, Princeton, N.J., 1969.

Smith, J. T.: *Nollekens and his Times*, 2 vols., London, 1829 (2nd edn).

Stevenson, W. H. (ed.): *The Poems of William Blake*. Text by David Erdman, London, 1971.

Tayler, Irene: *Blake's Illustrations to the Poems of Gray*, Princeton, N.J., 1971.

Todd, Ruthven: 'The Techniques of William Blake's Illuminated Printing', *Print Collectors' Quarterly*, Vol. 29, No. 3, pp. 25–36.

—— *William Blake The Artist*, London, 1971.

William Blake Trust: Facsimiles of the illuminated books, edited with commentaries by Sir Geoffrey Keynes, produced by the Trianon Press, Paris, as follows:

Songs of Innocence, 1954.
Songs of Innocence and of Experience, 1955.
Jerusalem [1950].
Jerusalem (in monochrome) [1953]. This is not a true facsimile.
The Book of Urizen, 1958.
Visions of the Daughters of Albion, 1959.
The Marriage of Heaven and Hell, 1960.
America, 1963.
The Book of Thel, 1965.
Milton, 1967.
The Gates of Paradise, 1968.
All Religions are One, 1970.
There is No Natural Religion, 1971.
The Book of Ahania, 1973.
Jerusalem (The Cunliffe copy), 1974.

The Song of Los, 1975.

In addition to facsimiles of the illuminated books, the following reproductions and facsimiles of other works have been published by the Trust:

William Blake's Illustrations to the Bible, London, 1957.

William Blake's Water-colour Designs for the Poems of Thomas Gray, London, 1972.

The reproduction in reduced format of William Blake's Water-colour Designs for the Poems of Thomas Gray, London, 1971.

Other reproductions and facsimiles of note include the following:

The Blake-Varley Sketchbook of 1819. Introduction and notes by Martin Butlin, London, 1969.

Blake's Grave . . . Being William Blake's illustrations for Robert Blair's The Grave . . . with a commentary by S. Foster Damon, Providence, R.I., 1963.

Blake's Job William Blake's Illustrations of the Book of Job, with introduction and commentary by S. Foster Damon, Providence, R.I., 1966.

Illustrations of the Book of Job, London and New York, 1902.

The Illustrations of William Blake for Thornton's Virgil, Introduction by Sir Geoffrey Keynes, London, 1937.

Illustrations to the Divine Comedy of Dante, New York, 1968.

The Note-Book of William Blake. Edited by Geoffrey Keynes, London, 1935.

The Notebook of William Blake. Edited by David V. Erdman with the assistance of Donald K. Moore, Oxford, 1973.

Songs of Innocence and of Experience. Introduction by Sir Geoffrey Keynes, London, 1967. Also issued in paperback by the Oxford University Press in 1970.

Vala or The Four Zoas with a study by G. E. Bentley, Jr. Oxford, 1963.

The American Blake Foundation, Illinois State University, Normal, Illinois, is publishing a series of monochrome facsimiles of the illuminated books, edited by Roger Easson and Kay Parkhurst Easson, with Robert N. Essick as associate editor. Vol. I, *America*, with an Introduction by G. E. Bentley, Jr, was issued in 1974.

Wilson, Mona: *The Life of William Blake*, new edn., ed. by Sir Geoffrey Keynes, London, 1971.

Wright, John: 'Towards Recovering Blake's Relief-Etching Process', *Blake Newsletter*, Vol. VII, pp. 32–39.

Index